Renate Klein

Draw Portraits

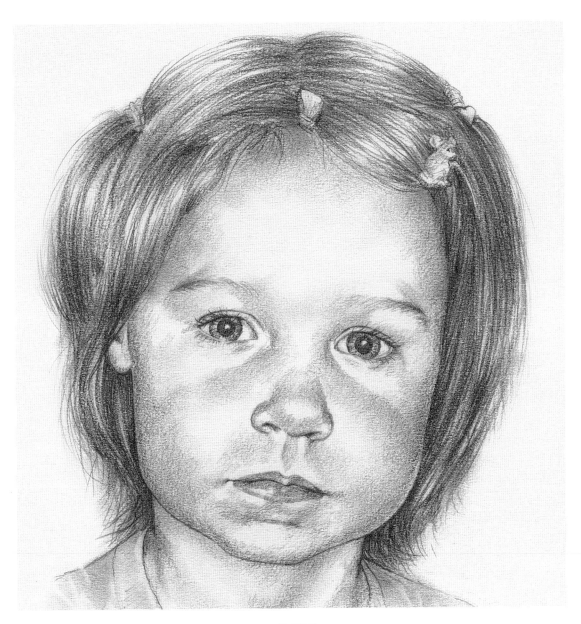

SEARCH PRESS

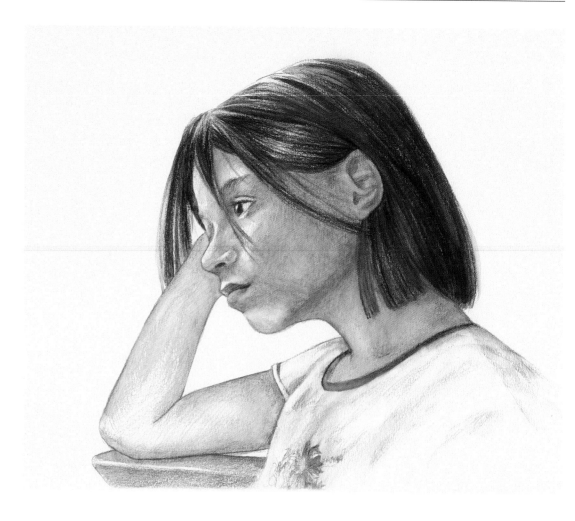

First published in Great Britain 2011 by Search Press Limited,
Wellwood, North Farm Road, Tunbridge Wells, Kent TN2 3DR

Originally published in Germany 2005 by Englisch Verlag GmbH, Wiesbaden as Workshop Zeichnen: Porträt

Copyright © Englisch Verlag GmbH, Wiesbaden 2005

English translation by Cicero Translations

English edition typeset by GreenGate Publishing Services

All rights reserved. No part of this book, text, photographs or illustrations may be reproduced or transmitted in any form or by any means by print, photoprint, microfilm, microfiche, photocopier, internet or in any way known or as yet unknown, or stored in a retrieval system, without written permission obtained beforehand from Search Press.

ISBN: 978-1-84448-696-0

Photos: Frank Schuppelius
Production: Achim Ferger
Printed in China

Draw Portraits

1 9 2588002 6

Contents

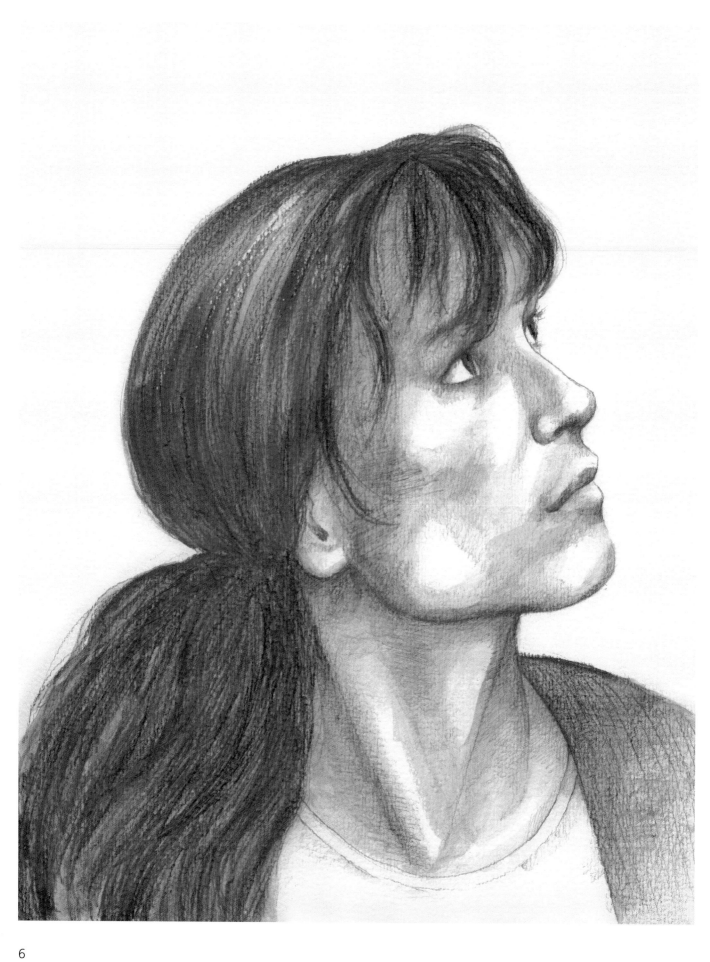

Foreword

People – their lives, experiences, personal tragedies, thoughts and feelings – fascinate us all. In art, all of the above can be appropriately expressed through portraits. Knowing about a person – their secrets, suspicions and fantasies – adds something extra to a portrait, which is also why drawing and viewing portraits is so pleasurable.

These complex considerations, along with the variety and subtlety of the human face, make the portrait a particularly demanding and difficult subject. Yet portraiture is something you can learn. Perfection may be difficult to achieve, but it is not absolutely necessary. Even imperfect portraits can move the observer – a quality that is more important than achieving an absolute likeness or perfecting a technique. This book should provide you with a basis on to which you can impose your own, individual style. Then, by following the instructions in the step-by-step practice pictures, you can work further on improving your technique. Usually, you will find that it is the desire to understand life portraits that leads to a preference for drawing them.

To start with, I would like to give you the most important basic rule for drawing a good portrait: the right way 'to see'. Look at faces at every opportunity, observe facial expressions and note changes in appearance when a person is viewed from different angles or under different lighting conditions. Soon, you will be drawing 'intellectually', selecting an appropriate technique, emphasising the important points and leaving out the irrelevant ones. I wish you every success with working through the lessons in this book and developing your own style of drawing portraits.

Renate Klein

The history of portraiture

In Ancient Egypt, people were portrayed according to the canon of proportions. Individual facial features were therefore not taken into consideration. It was not until the late classical period of Ancient Greece that portraiture found meaning, first through idealised pictures, and later, mainly in Roman art, through individual portrayals.

In Europe in the Middle Ages, idealised portrayals were mainly used within a religious context. It was not until the Renaissance that portraits were drawn for the purposes of capturing a likeness. With the help of anatomical studies, portraiture was perfected in the ensuing years (see the work of Albrecht Dürer and Leonardo da Vinci).

In Baroque times, portraits of nobility, the clergy or merchants were increasingly used for representative purposes (status pictures). They were less a reflection of the person than their position in society.

With the development of photography, portraiture has lost some of its significance and other demands have been made on the drawing of portraits. It is now less about purely external, formal likeness and more about capturing the nature of the person and a particular mood.

Yet even photography cannot completely replace portraiture, for it is only through practising with drawing implements that you can study and effectively represent the true anatomy and proportions of the face.

Anatomical studies helped portrait painters achieve perfection.

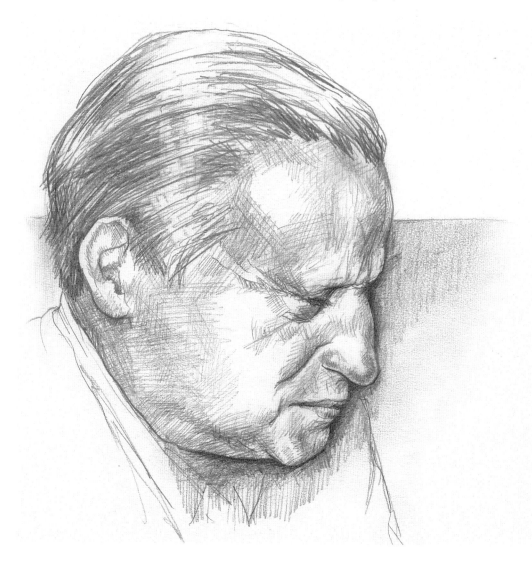

There are many ways of representing a person's nature.

Portraiture in practice

Lesson 1: initial considerations

The portrait is one of the most difficult subjects for an artist. With a lot of practice and patience, however, portraiture can be learned. Probably the most important prerequisite for a good portrait is **seeing**. This means looking carefully at faces and heads in general and, of course, at the particular sitter to be drawn.

If you want to draw a good portrait, the best recommendation is to use every opportunity to observe people. Even better, make **practice sketches** at the same time. Such opportunities are everywhere in everyday life, for example on public transport or at special events.

An important prerequisite is a basic knowledge of artistic **anatomy** and the **proportions** of the head. You will find diagrams and explanations to help you on the following pages.

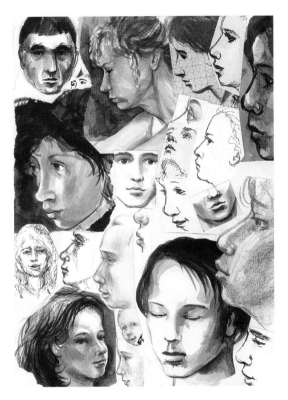

Learning goal
Learn how to decide on the lighting, method of picture construction and choice of materials.

Practise seeing details and sketch daily.

Make studies using different media – this will help you turn sketches into portraits.

What makes a good portrait?

Above all, a portrait should be **expressive**, reflecting the nature of the person, their character and perhaps also their life experiences and moods. The **subjective effect** the sitter has on the artist, and the relationship between artist and sitter, should also be recognisable. The same person will be seen differently by different observers, and a portrait may not even appear to have a great similarity with the sitter at first glance (as in an abstract or simplified representation).

The faces of older people can reveal a lot about their lives, as long as the portrait emphasises their individuality.

Getting started

The first thing to consider is the question of the subject. Is someone going to pose as a sitter for you? Are you going to work from photographs? Do you want to make a self-portrait using a mirror?

When **drawing a portrait using a sitter**, you should make sure that he or she is sitting comfortably and is relaxed. Depending on which technique you use, a sitting can last for up to an hour and sometimes even longer. You should schedule some breaks, so that it is not too demanding for the sitter. Ask your sitter to make a note of the pose. It can help to mark the position of the feet on the floor (e.g. with chalk), so that you can find the right pose after a break. Drawing from a sitter is preferable to **drawing from photographs**. The proportions, shapes and lighting conditions are easier to understand, particularly for beginners. You can also select the angle of vision, position of the head and the lighting.

Yet drawing from photographs still has its place. If you are unsure, you can take your time without worrying and you can keep drawing the same subject again and again. It is better to **draw children** from photographs, especially young ones, as they are not known for sitting still for too long! Suitable photographs are ones in which the face is large, clear and well lit. It is best to work with several portrait photographs of a particular subject.

The **self-portrait** has the advantage that your own face is probably the most familiar to you, enabling you to capture individual features well. And just as with drawing from a photograph, you can work without pressure of time.

For a self-portrait, you need a sufficiently large mirror. The lighting must illuminate the face advantageously, while at the same time illuminating the work area well too. Select a pose that will enable you to work easily and also give you a suitable angle of vision in the mirror. To avoid changing position too much when working, the distance between you and the mirror and between you and the paper should be short and the working materials should be close at hand. As the position of your head and the expression on your face are bound to change while you are working, you should keep checking these.

It is helpful at the start to make a few quick sketches of various poses and angles of vision. You can also select the best lighting and even try out different drawing materials. This will help you work out how best to get the desired expression.

Picture construction

When sketching, you are also working on the optimal picture construction. There are a lot more possibilities than you might think.

Portraits can involve different **numbers of people**: single, double or group portraits. In terms of the picture detail, you can have a head portrait (head and neck), a head-and-shoulder portrait (head, neck and upper bust area), a half-length portrait (head, neck and complete bust), a half-length figure (head to knees) and the whole figure.

The examples in this book are head portraits or head-and-shoulder portraits, as the book is mainly about portraying the head and facial features. This is why a detailed background has deliberately not been filled in.

For portrait drawings, the best views, and therefore the most frequently used views, are the **full face** (en face), the **half profile** and the **three-quarter profile**. People with an interesting profile can also make an attractive composition in **side profile**. Another view is the **turned away (lost) profile**, where only the cheeks, tip of the chin, eye sockets and perhaps the tip of the nose can be seen.

Keep note of your sitter's pose so that you can carry on working after taking a break.

When drawing portraits of small children, it is easier to have a photograph to work from.

When working on a self-portrait, the mirror and working materials should be close at hand.

Head portrait head and neck.

Head-and-shoulder portrait neck and upper bust area.

Half-length portrait head, neck and complete bust area.

Half-length figure head to knees.

Whole figure complete person.

Composition

When making your initial considerations and preparatory sketches, you should give some thought to how you can make the picture more exciting and therefore more interesting through the correct use of **compositional contrasts**.

You can consciously contrast areas of movement with quieter areas by, for example, leaving the background white around a head of lively hair, or at least leaving it unstructured.

You can also use the **light/dark contrast** for an exciting composition, by selecting the lighting so that a shadow falls on the face or behind the head.

Even with fair-haired sitters, a shadow behind the head or a darker background will give a good contrast.

The composition is also determined by the **content of the picture** and how it is **arranged** on the support. It is best not to place the head right in the centre of the picture but to position it to one side so that you produce two different-sized background areas.

For individual portraits, **portrait format** is usually chosen. **Landscape format** can, however, also be used as an interesting arrangement if a larger, quieter background area forms a contrast to the head portrayed.

Compositional contrasts bring the picture alive.

Compositional aids
- *Light/dark contrast in the content of the picture or the way it is lit.*
- *Portrait or landscape format.*

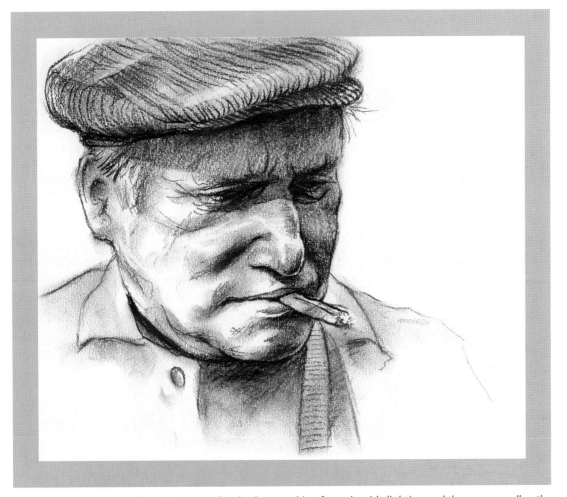

In this charcoal drawing of an older man, the shadow resulting from the side lighting and the cap, as well as the lines and the direction of the accessories (cap, cigar and jacket), make for an exciting composition. The format and the cropping of the subject reinforce the effect.

Light and shade

The three-dimensional shapes of the face are only visible due to the areas of **light and shade**, which are influenced by the lighting. Try out different **light sources**. Harsh side lighting can emphasise striking, manly facial features, whereas softer, indirect light is right for a delicate child's or woman's portrait.

In **diffuse light**, there is barely any shadow on the features so the shapes can really only be portrayed by marking the boundary lines. However, if the light comes from the side, the shapes of the features, such as the nose and the cheekbones, can be clearly emphasised through the shading. The illuminated parts remain light – they are left unshaded. The dimmer the light, the darker the shading. Begin with the large areas of shading and then move on to the smaller shapes later.

The direction and intensity of the light determines which areas of the face are lit and which are shaded.

Sunlight outdoors.

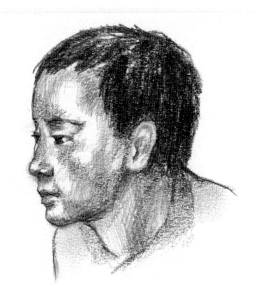

Diffuse daylight indoors.

Hatching can run diagonally, randomly, crossways or parallel.

The more layers of strokes that are drawn on top of one another and the heavier you press on the drawing implement, the darker the hatching will be.

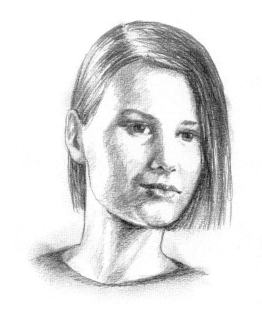

Lamplight from the left is reflected off a light-coloured wall on to the right of the sitter.

Shading

Depending on the type of drawing material used, there are various possibilities for drawing shadows. For quick sketches, simple, diagonal hatching or loose, random hatching is most suitable. The selection of drawing implement has no role to play here. For precise drawings, the shaded areas can be portrayed using hatching that follows the shape of the face. When using crosshatching or feathering (fine, linear or overlapping hatching strokes), follow the line of the shape by curving the lines. This somewhat time-consuming technique, which was used by Old Masters, such as Michelangelo, is particularly suitable for pen-and-ink or pencil drawings. As with all hatching techniques, you can deepen the tones by drawing several layers of strokes on top of one another or by pressing harder on the

paper with the drawing implement. By using soft pencils, charcoal or chalk, you can also work across **large areas**. By varying the pressure on the pencil, you can differentiate between light and dark areas. Another quick technique is to use the broad side of a short piece of chalk or charcoal. Textured paper can also produce an interesting granulated effect here.

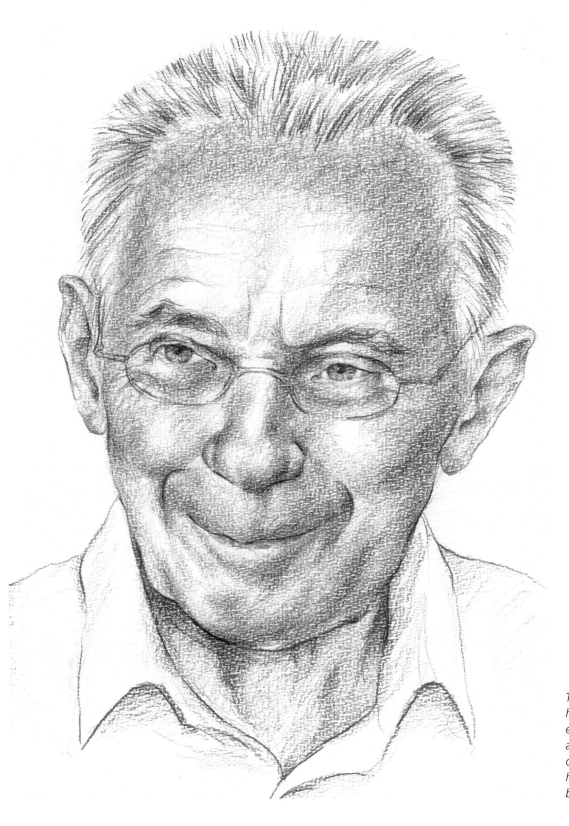

The textured paper used here gives a granulated effect in this example of an older man. The different coloured hatching is overlaid and blends well optically.

On rough-textured paper, move the pencil to and fro more frequently to make the tone darker.

If you are using rough-textured paper and want to make the surface texture clearly visible, do not press too hard. That way the lead from the pencil will adhere to the raised areas and not the indentations, leaving the grain of the paper visible. For darker tones, do not press harder; instead, move the pencil back and forth several times. The grain of the paper causes more of the pigment to be released and the tone gradually becomes darker.

With soft materials such as charcoal, lithographic crayons and soft pencils, tones can be quickly and easily created by **wiping your fingertip** over them. This creates soft, light shading. First draw the shaded part using light strokes.

*You can smudge pigments using your finger or a stump to create **soft shading**.*

Then wipe your finger over the area until the individual strokes almost or partially disappear and blend into a soft tone. Continue working in this way, alternating pencil and finger. You can also take some pigment with your finger from a part that has already been shaded dark and wipe it on to another area. When wiping on to smaller areas and details, such as the lips, use a stump (paper blender).

You can combine different techniques in one portrait but take care to ensure that the drawing still forms a single harmonious unit.

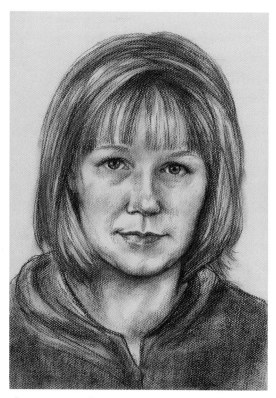

The structure of the shaded paper comes out well here. The chalk pencil is moved across the paper using a light to medium pressure.

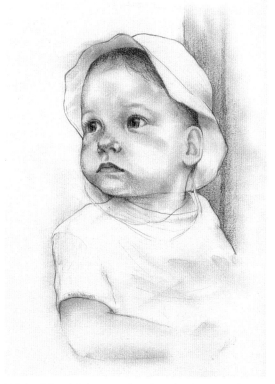

With this child portrait, the shading is almost exclusively created by wiping. This emphasises the delicate, smooth quality of the skin.

Practical exercise

First select a portrait photograph and determine the picture content. Now try out the subject on different papers with different light effects and hatching techniques. Compare your results to see which you prefer.

Lesson 2: the artistic anatomy of the head

Artistic anatomy only relates to the parts of the body that are relevant for the external appearance of a person, i.e. the bone structure and muscular system. When drawing portraits, it is useful to know the shape of the bony skull and the muscles in the head. They form the basis for the proportions, size and shape of the head and face.

The bones of the skull are essentially similar in adults, apart from slight differences. The individual shapes of the face are largely determined by the construction of the muscles, fatty tissue and skin characteristics. The nasal bone forms the upper third of the nose. Varying-shaped cartilage is responsible for all the different shapes of noses. The relatively thin muscle cords in the face move the jaw, mouth and eyelids. Even the tiniest of muscle movements can alter the expression on a face. The muscles of the throat and neck support and move the head, and are also involved in other body movements, which is why they are particularly pronounced in sportsmen and women.

Learning goal
Learn the basics of anatomy, which are necessary for artistic work.

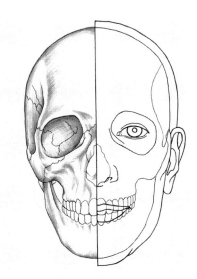

The bony skull – front view.

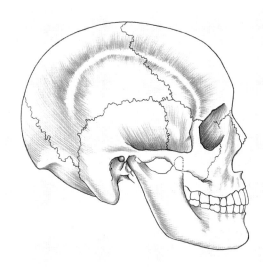

The bony skull – side view.

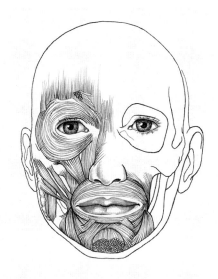

The muscles in the face – front view.

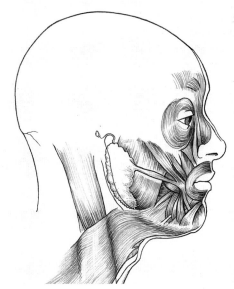

The muscles of the head – side view.

Portrayal of the head

Basic shapes

There are some techniques you can use to help produce an anatomically accurate drawing from the outset. For the **front view**, first draw two overlapping circles: the larger circle encompasses the upper part of the skull to the bottom of the nose; the smaller circle extends up from the jaw line to the eye sockets.

The pattern for the **profile** is similar but this time egg shapes are used rather than circles. These overlap one another at an angle.

With the **half profile**, you move between these two drawing aids according to the view.

Then you can sketch the possible positions of the eyes, nose, mouth and ears, hairline and throat using the guidelines as needed. Initially, just work using thin lines, which can easily be rubbed out with an eraser if necessary. Then you will need to adopt the proportions of the sitter. If, in front view, the head is looking downwards or the angle of vision is from above, the upper circle is elongated into an oval and the lower half of the face is pushed underneath. The reverse is true for an angle of vision from below.

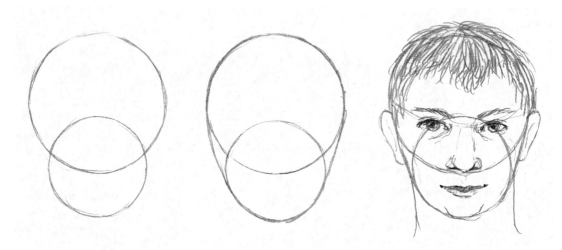

The shape of the head in the front view is based on two overlapping circles.

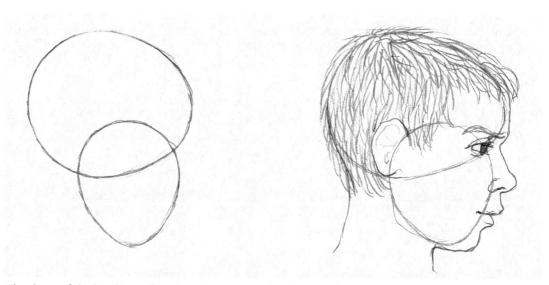

The shape of the head in profile is based on two overlapping egg shapes.

Proportions

The proportions of the head concern the relationships in terms of size and shape of the **head** as a whole and the inner shapes (eyes, nose, mouth and ears). Despite individual differences, the proportions fall within a standard range, with the result that the average human head can be divided into a general grid. You should learn the most important generalised dimensions for the front view:

- The **head** is around one and a half times as high as it is wide at the level of the cheeks.
- The **eyes** are on the horizontal midline of the whole head.

- The **width of the eyes** goes five times into the width of the head at the level of the eyes.
- The **tip of the nose** sits roughly in the middle between the eyebrows and the chin.
- The **dividing line between the lips** is at roughly a third of the distance from the nose to the chin.
- The **bottom edge of the lower lip** is roughly in the middle of the nose and chin.
- The **ear** is as long as the nose; it sits between the eyebrows and the tip of the nose.
- The **distance between the eyes** corresponds to the width of an eye, and this is also the **width of the nose at the nostrils**.

The generalised proportions of the head can be drawn up in a grid.

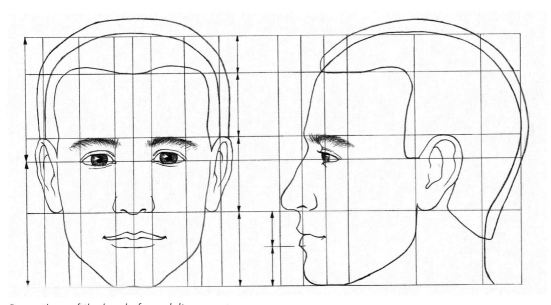

Proportions of the head of an adult man.

To assess proportion accurately when drawing from nature, whether your subject is a piece of architecture, a figure or a portrait, you need to use the technique of measuring up. Hold your pencil with an outstretched arm in the direction of the subject. Your arm must always be stretched out fully, so that the distance is always the same. The distance to be measured (e.g. tip of nose to chin) can easily be found by closing one eye and marking the pencil with your thumb. Either work measuring like this from the start and transfer the measurements directly on to the paper or use it simply to check certain measurements, using the system above to compare the proportions.

Whether you use this measuring technique or not, you must **observe accurately**. By continually comparing the emerging drawing with the sitter, you'll get the correct proportions and spot any mistakes. A **tentative stroke** will give a proper feel for the proportions. Use several light, scribbled or sweeping strokes drawn next to one another. By continually comparing with the sitter, you can see the correct lines emerging and emphasise them. This is how you work on the individual facial features.

Take the measurements of your sitter with the help of a pencil.

The proportions of a child's face do not correspond to those of an adult.

Children

The **proportions of a child's head** are different from those of an adult. Children's faces are broader and the facial features are soft and not so pronounced. The upper area of the head is larger in relation to the lower half of the face. The younger a child is, the clearer the difference. This is due to the rapid development and enlargement of the brain in babies and young children. This causes the skull to grow faster than the jaw area.

The shapes of the face, in particular the cheeks and the chin, are more rounded in children than in adults. The distance between the eyes (that are also rounder) is wider and the iris is larger in comparison to the visible white eyeball. Children's noses are flatter and shorter and there is a greater curve to the gap between the nose and the forehead (seen most obviously in profile). As children age, so their heads take on the proportions of an adult head.

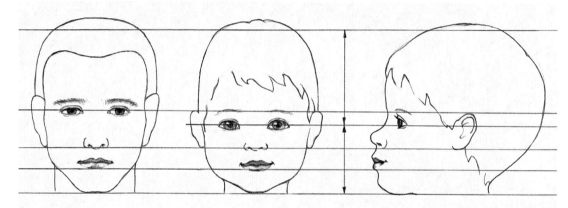

The proportions of the head of a boy and a young child.

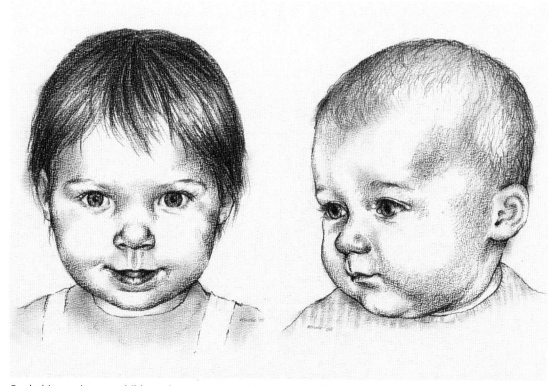

For babies and young children, the upper part of the head is still quite large in comparison to the face.

Male and female heads

Men's faces appear more angular than those of women and the bones (e.g. above the eyebrows) stand out more. The eyebrows are straighter and bushier.

Women's heads are rounded; their lips are full and the nose is not as pronounced as in men. Often the eyes are bigger and the distance between the eyes and the eyebrows is greater than in men.

Angle of vision

The head is roughly symmetrical and the vertical midline of the face forms the axis of symmetry. Yet it is not a perfect symmetry, as each face is somewhat irregular. When sketching using a grid, you should assume symmetry and then draw in any known deviations. As a head is not a flat shape, rather a three-dimensional one, the flat nature of a grid needs to be converted into a spatial structure using **meridians**. These meridians clearly show the shifting of the proportions from a different angle of vision (see the illustrations).

If the observer is looking **from the same height** at a person portrayed in half profile, the half of the face that is turned away is narrower and the nose turns into this half of the face. The side of the nose that is turned away is barely visible, yet you can see completely the side of the nose and the nostril of the side that is turned towards you.

When looking from below, or with a head that is tilted back, the parts that are facing upwards are shortened, such as the forehead, the bridge of the nose and the lower lip. Not much of the top of the head can be seen. The ears appear to run downwards.

When looking from above, or with a head hanging down, the upper part of the head takes up the largest area while the shapes in the lower part are shortened. The upper eyelids, nostrils, top lip and the part of the chin that is turned away are barely visible or unseen.

Women's faces are generally rounder and softer than those of men.

View from the same height in half profile
The half of the face that is turned away looks narrower.

View from below
The upper area of the head is shortened.

View from above
The lower area of the head is shortened.

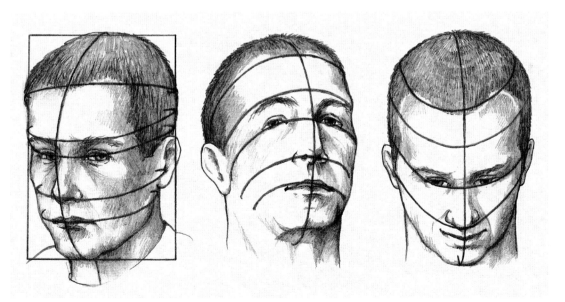

The meridians of the head, showing how the proportions shift with a different angle of view. From left to right: view from the same height (half profile), view from below (half profile) and view from above (front view).

Eyes

The individual expressions of the eyes must be taken into consideration when drawing portraits.

The eyes are the most expressive and lively element of the human face. It is important to know about the shape and structure of the eyes so that they appear natural and alive. The eyes are made up of round eyeballs that sit in the bone sockets beneath the surface of the forehead and are protected by the eyelids. The lower, bony part of the eye socket often appears through the tissue that lies over it, making the rounded to angular shape visible – the so-called rings under the eyes. The outer corner of the eye is usually a bit higher than the inner one, so that the **eye is at a slight slant**. The inner corner of the eye has a tiny red knot with a little conjunctiva fold. The colour of the iris varies across all possible shades of dark or light brown, blue, grey and green. The pupil in the centre of the iris appears black. The eyelashes grow on the outer edge of the eyelids. The eyebrows can be very different: narrow, wide, bushy, smooth, short- or long-haired, thick or sparse. The shape of the eyebrows can vary from straight to curved and their direction and distance from the eyes can be quite different.

When drawing eyes, take the following into consideration:

- The curvature of the eyeball can be seen through the lids.
- The upper eyelid often throws a shadow over the eyeball.
- Light sources often cause light reflections (glints) in the eyes, which make the eyes appear shiny and alive.
- In profile, the eye appears simplified like a triangle.
- The iris and the pupil are elliptical when viewed from the side.
- The curvature of the eyeball and curved parts around the eye must be indicated using light and shade.
- The lids have a certain thickness that in side view is visible along the lower lid and also often from the front view.

> *Tip*
> *A person's right eye is on the left side of the face when you are looking at it. However, it is drawn as the right eye in relation to the person opposite.*

Step-by-step practice picture: right eye

> *Materials required*
> ✦ *Drawing paper*
> ✦ *HB and 4B pencils*

1 First plot the basic shapes with thin lines using an H or HB pencil: start with the eyeball and shape of the aperture, followed by the iris, the pupil and finally the eyelids. The glint – reflected light – is left blank.

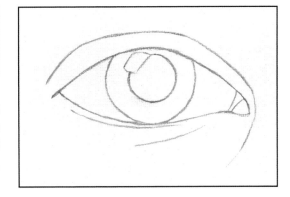

1 Plot the basic shapes.

2 Now lightly hatch in the shading and tone of the iris and pupil. First use a medium-hard pencil such as an HB. Darker areas, such as the pupils, can be emphasised with a soft pencil. Light reflections must be left blank.

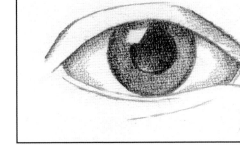

2 Hatch in shading and tone.

3 Now shade the darkest areas with the soft pencil (4B). Sharpen this pencil well for drawing the eyelashes. That way, you can draw the lashes along the eyelid thickly, but then run them out to thin lines. Important contours, such as folds in the eyelids, are gone over again. Add other detailing such as the radial pattern of the iris.

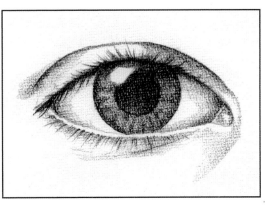

3 Emphasise individual contours and add details.

Nose

The nose is often the most typical feature of a face. The only bone is in the top third. The individual shape of the nose comes from cartilage and the fibrous fatty tissue from which the nostrils are made. The basic shape of the nose can be compared with a triangle (wedge), yet there are very many different kinds of noses: snub noses, aquiline noses, straight, hooked, narrow or wide noses.

Viewed from the front, the typical nose shape is less obvious than in profile or half profile. That is why the correct shading is the only way to define the shape clearly.

The nose looks different from each angle of vision. This can be made clearer by imagining it as a wedge that changes in each new perspective.

When drawing the nose, pay attention to the following parts:

- The bony area.
- The upper and lower cartilage.
- The side of the nose.
- The nostrils (darker shading at the top edge that turns lighter below).

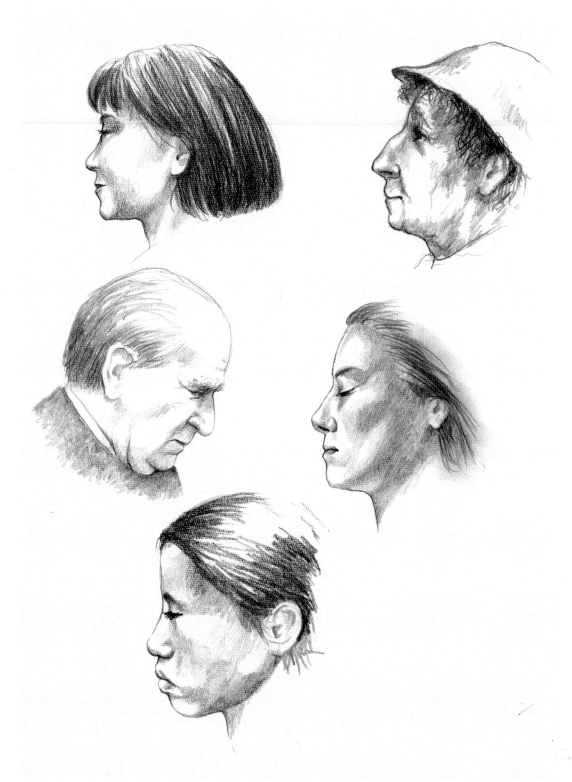

Profile views with various shapes of noses.

Step-by-step practice picture: nose from front view

> **Materials required**
> ✦ *Drawing paper*
> ✦ *HB and 4B pencils*
> ✦ *Eraser*

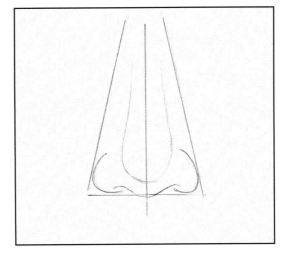

1 *Plot the triangular shape of the nose.*

1 Starting with a guiding triangle, draw the outlines of the nose with the HB pencil. Draw the tip of the nose, the sides and the nostrils symmetrically around the midline.

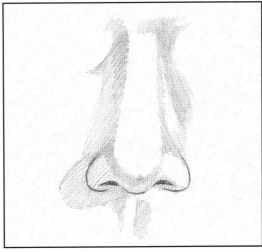

2 *Shape the nose with hatching.*

2 Erase your guidelines and add shading with diagonal hatching, so that the shape of the nose starts to become visible. Draw in the nostrils and shape the upper edge, lightly fading out below.

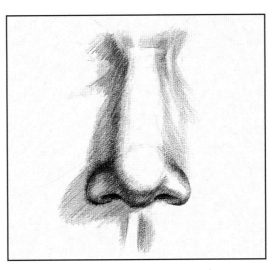

3 *Deepen the shading where required.*

3 Finally, emphasise the deeper shading with a soft pencil (4B) and strengthen the contours of the sides of the nose and the nostrils.

Step-by-step practice picture: nose in half profile

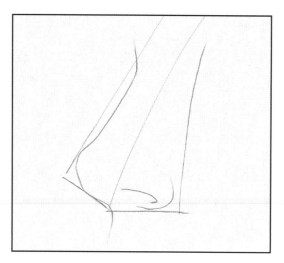

Materials required
+ *Drawing paper*
+ *HB and 4B pencils*
+ *Eraser*

1 Plot the wedge shape of the nose.

1 With the aid of some wedge-shaped guidelines, capture the outlines of the nose. The profile lines in particular should be drawn precisely.

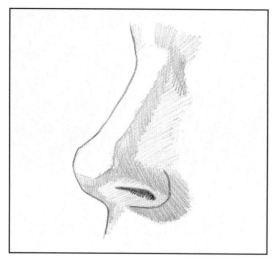

2 Lightly hatch in the shadow.

2 Remove your guidelines and go over the correct outlines with the HB pencil. Lightly hatch in the shadow. Make sure that the direction of the hatching follows the shape of the nose. The nostril is drawn darker, with strong hatching becoming lighter below.

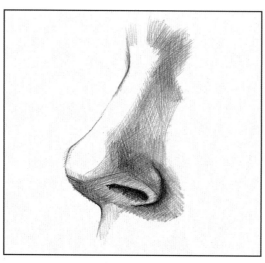

3 Go over the dark tones and contours again.

3 Emphasise the shadows by going over the hatching with the soft pencil (4B). Go over the darkest contours again.

Mouth

Shapes of mouths can vary greatly. These variations are not purely genetic but also relate to how the muscular system around the mouth is used. The basic shape of the lips is similar for all people, yet they can appear to be quite different.

When drawing mouths, take the following into consideration:
- The width of the mouth
- The thickness of the lips
- The sweep of the lines and the shape of the parts surrounding them (chin and upper lips).

The little notches at the corners of the mouth are also important for the expression of the mouth. Depending on their direction, they can give a strong, mocking or friendly appearance. The line at the opening of the mouth is the darkest and should therefore be more strongly emphasised than the outer lines of the lips. The shape of the lips and their sometimes rough and uneven surface texture can be represented with clear strokes and by light and shade.

Step-by-step practice picture: mouth

Materials required
- *Drawing paper*
- *HB and 4B pencils*
- *Eraser*

1 Plot the outlines of the mouth with a light touch using the HB pencil, merely indicating any contour of the lower lip. The line between the lips should be captured precisely – the sweep and direction of this line is important. The corners of the mouth and the philtrum (furrow between the nose and lips) should also be drawn in.

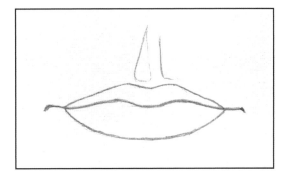

1 Plot the outlines lightly first.

2 Now add the initial shading. Make sure that the strokes follow the shape of the lips. The lip contour can be removed in places if necessary, as here with the lower lip, whereas the line between the lips is made stronger.

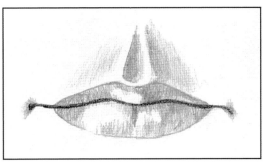

2 Add shading, making sure that the hatching follows the shape of the lips.

3 Make the shading stronger. Use hatching to draw the folds and texture of the lips, at the same time taking note of their curvature.

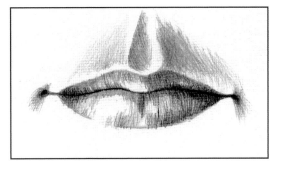

3 Emphasise dark areas of shading.

Ears

Depending on the hairstyle and angle of the head, the ears are not always visible or may be only partly visible in a portrait. As they are seldom as important as the facial features in terms of expression and likeness, they are sometimes only hinted at when drawn.

Nevertheless they must be drawn in an anatomically correct manner and correspond to the sitter's in terms of size and formation. Despite individual peculiarities, the basic construction of the ear is the same in all people.

Step-by-step practice picture: ear from front view

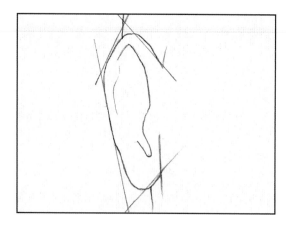

1 Plot the basic egg shape of the ear.

> **Materials required**
> ✦ *Drawing paper*
> ✦ *H, HB and 4B pencils*
> ✦ *Eraser*

1 The basic shape of the ear is a narrow oval, tapering downwards (an egg sitting on its point). Using the H pencil lightly mark the guidelines for the ear and indicate the main contours. The guidelines make it easier to capture the shape.

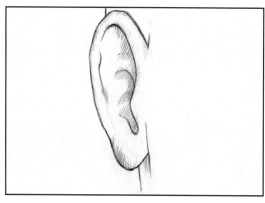

2 Add the shading in the inner areas.

2 Erase the guidelines. Mark the darkest areas (shading in the inner areas) using a medium-hard pencil (HB). Make sure that the hatching follows the shape.

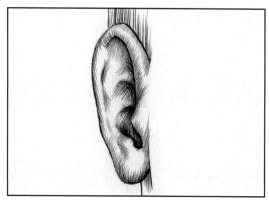

3 Make the hatching stronger and emphasise the important contours.

3 Develop the hatching further using denser and overlapping lines. For the darkest areas, use the soft pencil (4B). Go over the most important contours using this pencil too. The pencil needs to be well sharpened for the hatching. Soft pencils need re-sharpening frequently, as they wear out more quickly than hard ones.

The shape of the inner ear is not an easy one. It is therefore advisable to practise drawing it in various studies from different angles.

The inner ear is made of cartilage; the ear lobes are made of the same fibrous substance as the nostrils. The ear is positioned roughly between the eyebrows and the tip of the nose and it can vary considerably in size. Viewed from the side, it appears slightly tilted. The opening of the auditory canal is behind the hinge of the jawbone.

Step-by-step practice picture: ear in profile

> *Materials required*
> + *Drawing paper*
> + *H, HB and 4B pencils*
> + *Eraser*

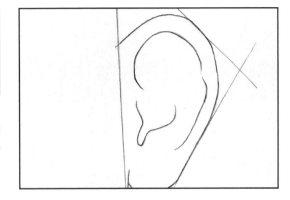

1 Plot the basic egg shape of the ear. As can be seen from the guidelines, a triangle can also be used as a guide. Use an H or HB pencil.

1 The basic shape here is a triangle.

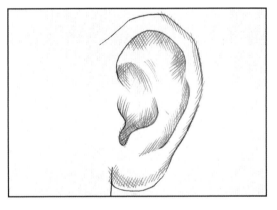

2 Erase the guidelines and then hatch in the shading of the inner ear using a well-sharpened HB pencil. Follow the shape of the ear.

2 Hatch in the shading, following the shape of the ear.

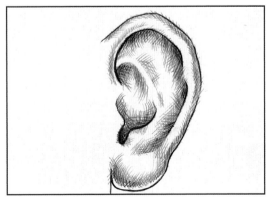

3 Make the darkest shading stronger by going over the hatching using the 4B pencil. Go over important contours with the soft pencil too.

3 Go over important contours and darkest shading with a soft pencil.

27

Hair

As hair is very individual, it must be carefully observed and captured.

Hair is very important for the expression of the portrait. The way it falls, its texture and its shade significantly influence the overall impression of the head. As hair differs greatly in terms of length, colour, shape and texture, **careful observation** is required to recognise the peculiarities. However, when drawing, you can follow a general approach, despite individual differences.

First, outline the area taken up by the hair using a few strokes. Then set out the darker shaded areas using hatching or lines following the way the hair falls. It is advisable to do this using fairly thick pencils as well or by smudging a soft material such as charcoal. In these larger areas of dark and medium tone you can draw in the flow of the hair afterwards with a sharpened pencil. The strokes should take account of the character of the hair – soft, sweeping lines for curls; short, straight lines for bristly hair.

Gleaming areas are shown by leaving these areas blank or by erasing them.

To achieve an effect of shine on the hair, the areas that reflect the light should be left blank. The lines depicting the flow of the hair can be broken off at these places, or removed afterwards using a kneadable eraser. Depending on how you want the drawing to look, the hair can be drawn in detail or indicated with just a few strokes.

Step-by-step practice picture: long hair

Materials required
+ *Drawing paper*
+ *H, HB and B pencils*
+ *Eraser*

1 Outline the mass of hair using a hard pencil (H) and indicate its flow with some initial lines. First make these basic lines very light. Here, the long, smooth hair is drawn from the parting using equally long, lightly sweeping lines.

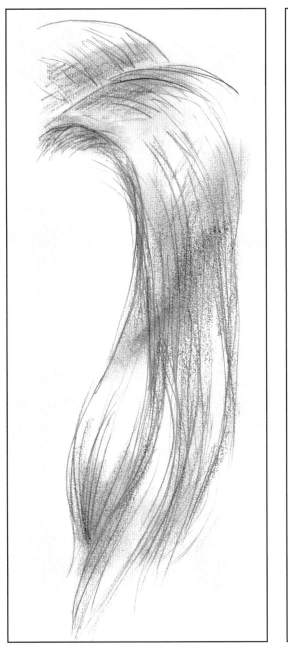

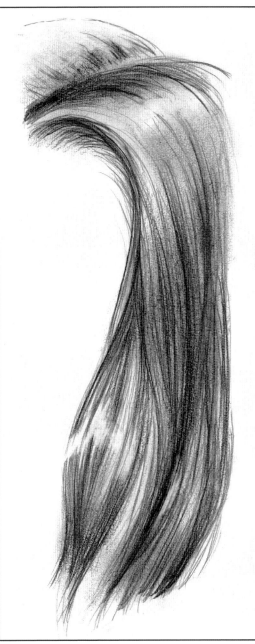

1 Lightly indicate the mass of hair.

2 Develop the sweep and texture of the hair.

3 Add dark accents and glints.

2 Add more lines using an HB pencil, paying attention to the sweep, curvature and texture. Light-reflecting areas can be left blank or the lines removed afterwards with an eraser. Make dark parts darker by drawing with the soft pencil and then smudging it.

3 Continue in the same way. The strands are made to look three-dimensional by accentuating them with a soft, well-sharpened pencil. Gleaming areas can be added by erasing them as desired.

Prepare some practice sheets on which you have drawn eyes, noses, mouths and hairstyles in different views and shapes and use them as reference material.

Practical exercise

Lesson 3: drawing portraits using pencil and graphite

Pencil – materials and method of working

Learning goal
Learn how to draw portraits using a pencil and water-soluble graphite pencil; work on the particular differences in the proportions of children's heads compared with those of adults.

Pencils are the most common drawing implements. They are very versatile and especially good for beginners because they are easy to use. Pencils are not only made from lead, but also from a blend of graphite and clay. This is why they are also called graphite pencils. They are available in finely graded levels of hardness from the hardest (10H) to the softest (9B). They come in various forms:

- with a wooden barrel and a round lead;
- with a rectangular lead as a sketching or carpenter's pencil;
- as a retractable pencil;
- as a graphite pencil without a wooden barrel 2–8mm (⅛–⅜in) in diameter.

Basic materials
- *Pencils from 2H to 6B*
- *Stump (paper blender)*
- *Kneadable eraser and hard eraser*
- *Small knife*
- *Sandpaper*
- *Drawing paper in different textures*
- *Paper to protect from smudging*
- *Fixative*

For portrait drawing, a basic range of **four to five grades from 2H to 6B** is sufficient. Hard leads are suitable for fine and light lines. If you do not press too hard, you can use hard to medium grades for sketching – light lines will not spoil the effect. Strong, dark strokes and paint effects can be achieved with soft, light, smudgable pencils. When smudging soft pencils, you can use your fingertips. For larger areas, use a crumpled **paper tissue** and for detailed work use a **stump** (paper blender), available from specialist art shops.

To remove soft pencil strokes, use a **kneadable eraser**. You can erase even the finest details with one of these by shaping it into a fine point. Use a **firm eraser** for hard pencils and for pencil strokes that have been pressed deeper into the paper. There are also hard erasers in pencil form that are useful for precise corrections. In general,

a softer eraser is preferable, as it will cause less damage to the paper. Erasers are not only used for correcting, but also for specific effects, for instance for placing glints in shaded areas (e.g. for hair and eyes).

Sharp knives are better for sharpening pencils than pencil sharpeners. They remove more wood, leaving more lead free. The lead can also be shaped as required using the knife and a piece of **sandpaper**.

The expression of the drawing is influenced not only by the pencils used but also by the **type of paper**. It is useful to try out effects with different types of paper that have smooth, rippled, rough or coarse-grain surfaces.

Textured paper is preferred when drawing portraits because it breaks the strokes and gives the drawing a softer appearance. To avoid inadvertently smudging the drawing with your hand (particularly with softer pencils), place a **second sheet of paper** under your drawing hand. If you use paper of the same quality for this, you can use it to try out the effects of different types of stroke and varying the pressure of the pencil.

In order to protect the finished drawing from smudging, it should be treated with a **fixative** when complete.

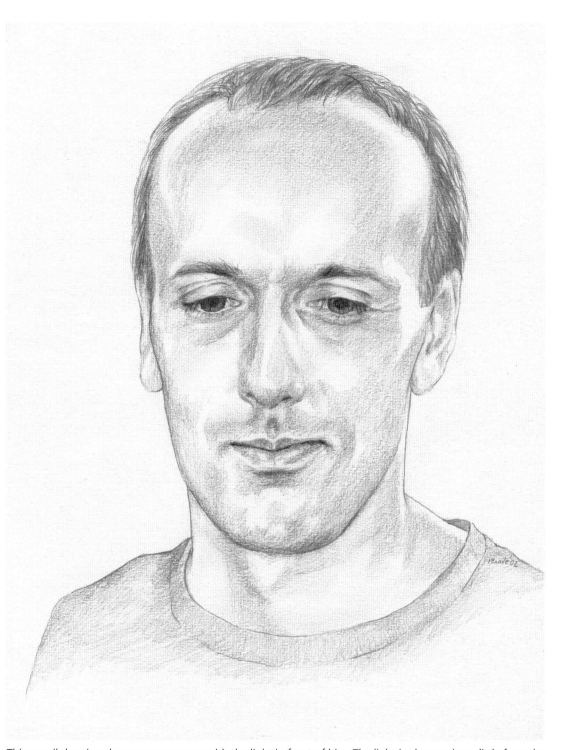

This pencil drawing shows a young man with the light in front of him. The light is also coming a little from the left, leaving his face as far as the top of his head and his right temple in shadow, though it is not a hard shadow. The facial features are drawn softly using a soft, blunt pencil passed loosely over the slight grain of the paper.

Step-by-step practice picture: young girl

Materials required
- *White drawing paper with slight grain, A4 to A3*
- *H, HB, 4B and 6B pencils*
- *Eraser*
- *Paper or tracing paper to protect against smudging*
- *Fixative*

As small children are too young to be sitters, a photograph showing the very expressive face of this two-year-old girl has been used to draw from. Light lines and soft shading – ideal for this portrait – are portrayed equally using a pencil.

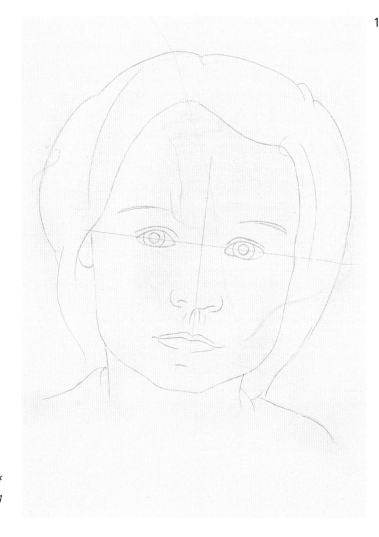

1 Plot the egg shape of the child's head using light strokes.

1 Start by drawing the rather round egg shape of the child's head on the paper, filling the sheet, but leaving sufficient space around the edge of the picture to make corrections. Use a medium-hard pencil (HB) for this, and run it lightly over the paper, so that it will be easy to erase if necessary. Horizontal guidelines show the right places for the eyes, nose and mouth, taking account of the fact that the head viewed observer is slightly tilted down to the right, so the guidelines are not quite vertical and horizontal, but slightly displaced. The horizontal 'eye line' is below the centre, as the upper part of a child's head is larger. Finally, the head of hair is defined.

The proportions should now be compared with those in the photograph – you can spot mistakes better when you step back a little and view the sketch from a distance. As you have not worked on any further details, corrections are easy to make.

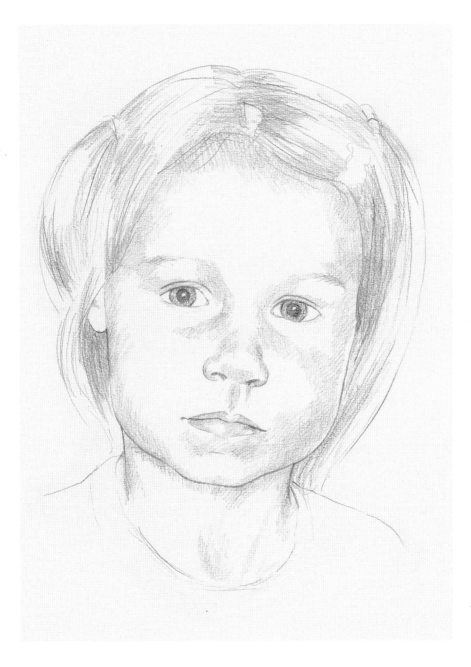

2 Work on the inner shapes and add the initial shading.

2 Once you are happy with the layout of the drawing, you can make the lines stronger, using a softer pencil, and work more precisely on the inner shapes (eyes, nose and mouth).

The shadows should be drawn lightly using loose hatching and the strands of hair indicated together with the hair clips.

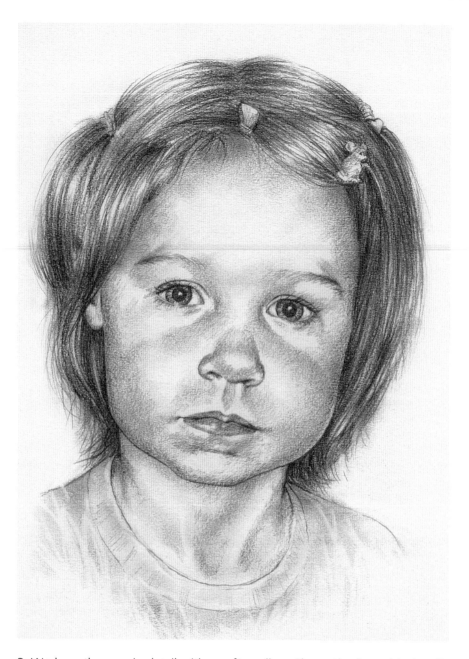

3 Continue to develop the drawing and, in places, smudge the shading so that it appears very soft.

3 Work on the eyes in detail with a soft, well-sharpened pencil. The iris is darkly outlined first and then filled with strokes radiating inwards that are drawn using decreasing pressure, so that they become lighter towards the centre. Emphasise the shadows at the appropriate places using a softer pencil (4B). Work on the nose, round cheeks and other shapes in the same way. Run a blunt pencil evenly across the paper without making visible strokes to capture the soft, smooth skin structure.

Shape the lips with the 4B pencil, leaving the glistening reflections blank. You can smudge the darker places in the hair with your finger. The lightest shadows on the face and neck can also be smudged to make them appear very soft.

Finally, draw in the eyelashes and eyebrows using a well-sharpened 6B pencil. The T-shirt is indicated using a few strokes and lightly smudged shadows with highlights added using an eraser. When finished, the drawing should be protected with a thin layer of fixative.

Water-soluble pencil – materials and method of working

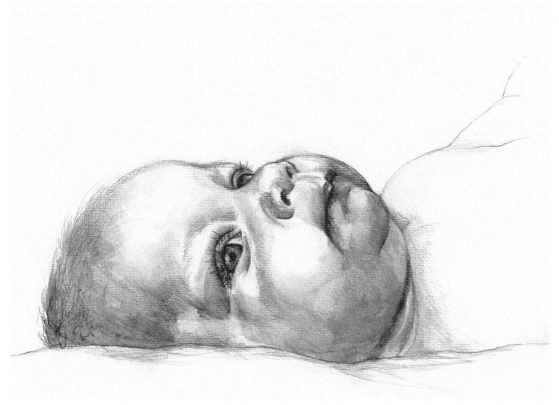

This drawing was produced with a water-soluble graphite pencil. The same image, drawn from a photograph, is re-created in red chalk on pages 49-51. Compare the different effects.

Water-soluble graphite pencils are different from pencils: they are an extremely versatile drawing medium that can be used like a pencil, yet they can also be diluted with water and applied with a brush to give a wash effect. The result is similar to a washed pen-and-ink drawing. Transferring the image is uncomplicated too, as water-soluble graphite can be erased. Only a little colour is needed for a light tone, which is why you should try out these effects first.

To prevent the paper from cockling, you need to use a **watercolour pad** or other **strong paper**.

Water-soluble graphite pencils come in several grades, with two or three pencils in **medium**, **soft** and, if needed, **very soft** being sufficient. To dilute the colour, you need **water** and a **watercolour brush**. Even the washed areas can be relatively easily removed using an **eraser**.

You can use water-soluble graphite pencils to draw in the usual way and then paint over specific pencil marks with a wet brush to create selective washes, or even dilute everything. You can also draw with the pencil on wetted paper or wet the pencil and draw on dry paper. These techniques create a darker shade than when working with the pencils dry.

First practise the wash technique using a simple subject.
Work using the whole of the brush as well as the tip.

Basic materials
- *Watercolour pad or other strong paper*
- *Water-soluble graphite pencils in medium, soft and very soft*
- *Fine to medium round watercolour brush*
- *Eraser*

Practical exercise

Step-by-step practice picture: young woman

Materials required
+ *Watercolour pad in beige, with a slight grain, about 20 x 30cm (8 x 12in)*
+ *2B and 6B water-soluble graphite pencils*
+ *Fine to medium round watercolour brush*
+ *Water*
+ *Fixative*

This seated young woman is listening to something someone near her is saying. The graceful way she holds her head, her soft profile and her attentive gaze make the subject an attractive one. The combination of graphite pencil and watercolour technique enables a play of graphite and paint effects that make the face appear very much alive.

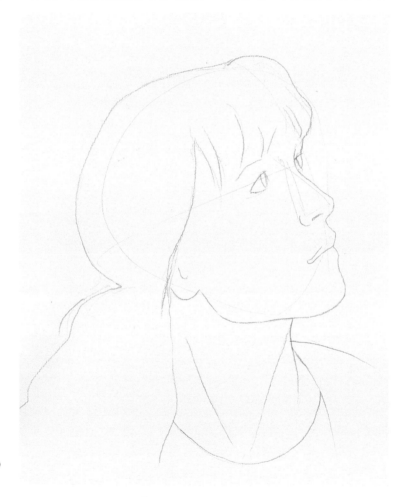

1 Plot the basic shapes of the face, paying particular attention to the profile line.

1 Using the harder water-soluble graphite pencil (2B), sketch out the basic shapes of the face without pressing too hard. The shape of the nose is based on a wedge shape. Pay particular attention to the profile line – it is important for the likeness. That is why the drawing must continually be compared with the sitter and corrected if necessary. It is useful to calculate all the distances by measuring (see page 17).

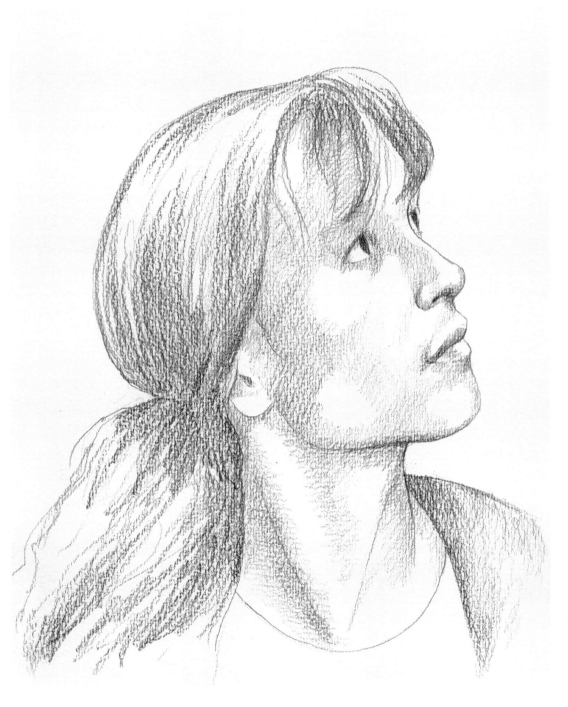

2 Add the shadows and then emphasise details and contours with the softer graphite pencil.

2 Now work on the shadows using a light stroke and dense hatching. The light, loose stroke leaves the rough texture of the watercolour paper visible. The graphite dust should only adhere to the raised areas of the paper, as otherwise the subsequent glaze could appear too dark.

Draw the flow of the hair and the upturned eyes with the soft graphite pencil (6B). Emphasise the contours with this pencil too. Compare your picture again with the sitter.

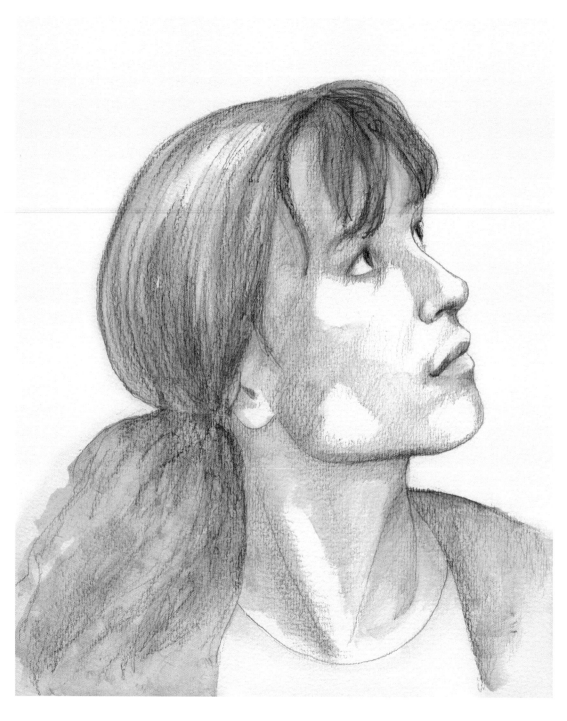

3 Use water and a medium pointed brush to wash over the initial shaded areas on the face and in the hair.

3 Moisten a medium-sized round watercolour brush with water. In its wet state, it comes to a fine point, so that you can work on large areas yet also use it for fine detail. Wash over the shaded parts on the young woman's face and in her hair with the moistened watercolour brush.

The graphite strokes are completely or partly diluted according to the desired effect. Use the body of the brush for washing large areas and the point of the brush for fine details.

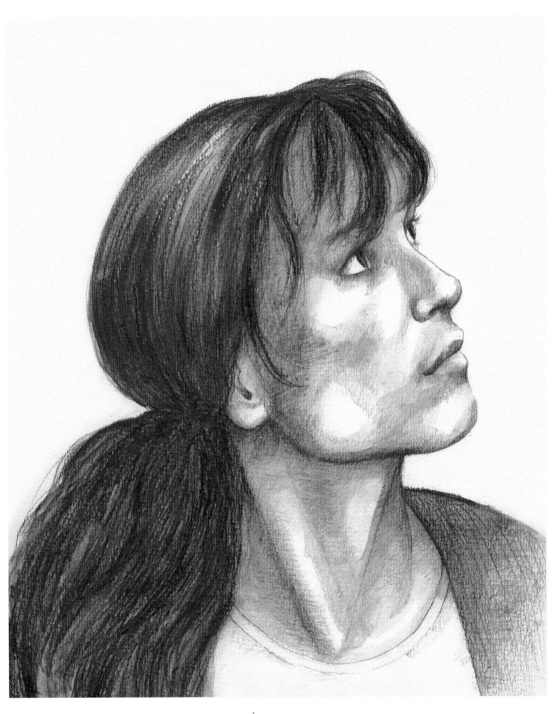

4 *Add further washes and work into wet areas with pencil to intensify the darkest tones.*

4 To achieve the correct shade of dark hair, draw in more hair, strand by strand, using the softer graphite pencil. Leave the light-reflecting parts blank. Finally, wash over the hair again and, in the areas that are still wet, draw in the darkest accents. Using the wet brush you can pick up the rich pigments from these dark areas and emphasise the tones of the face, for example around the eyes. Add some hatching in the larger shaded areas around the cheeks and neck, diluting it here and there with the brush. Work on the jacket a little more, indicating the fabric texture; a further wash darkens the grey tone.

Two-year-old child

Materials required

✦ *White drawing paper, about 20 × 25cm* ✦ *Medium round watercolour brush*
 (8 × 10in) ✦ *Water-soluble graphite pencil*

This drawing of a two-year-old child was made using a water-soluble graphite pencil. The lightly hatched shadows were diluted with the brush to soften them.

For added depth in the darkest shadows, a soft graphite pencil was hatched over the wet areas, and this technique was also used to add the tousled, soft curls.

Lesson 4: drawing portraits using charcoal

Charcoal – materials and method of working

Charcoal is easy to use and is excellent for live, large-scale and expressive portraits. When you want to work precisely and in detail, charcoal is a good medium to choose because it encourages a **looser stroke**. The effect is **more like a painting**, which is why charcoal is also excellent for quick sketches.

Charcoal is one of the oldest drawing materials. It is usually extracted from willow, beech (brownish/black) or vine (blue/black). You can also find charcoal sticks made from charcoal dust compressed with a binding agent, which can create a rich black, as well as powdered charcoal, which can be wiped over the paper.

Some charcoal sticks come with a casing, enabling you to work more cleanly with them. Sticks that are not in a casing have the advantage that they can also be used along the broad edge and can thus be used to shade whole areas.

When drawing portraits, **harder charcoals** are suitable for details and **soft charcoal** for shading. As the colour particles do not adhere to smooth paper, you should use **lightly textured to grainy paper**. To lighten or remove the charcoal, use a **kneadable eraser**. Charcoal can be made into the desired shape using a sharp knife or by rubbing with fine sandpaper.

There is virtually no other drawing technique that enables you to use the **effects of smudging**. Charcoal is easily smudged with the fingers, a cloth, cotton-wool balls or paper tissues. A **stump** smudges smaller areas very well too. As charcoal drawings can also be accidentally smudged very easily, they must be sprayed with **fixative** when finished.

Learning goal
Learn to make an expressive portrait using charcoal.

Basic materials
- *Lightly grained paper*
- *Hard and soft charcoal*
- *Kneadable eraser*
- *Small knife*
- *Fine sandpaper*
- *Cloth, cotton-wool balls or paper tissues*
- *Stump*
- *Fixative*

Hard charcoal is suitable for details and soft charcoal for shading.

Charcoal is particularly good for quick studies. A loose charcoal drawing can be made in ten minutes.

Practise drawing fine details and shading large areas first on a separate piece of paper. Use soft and hard charcoal. Add highlights using the kneadable eraser and lightly smudge the transitions with your finger or a stump.

Practical exercise

Step-by-step practice picture: young woman

Materials required
- *Lightly textured white drawing paper, about 21 × 25cm (8¼ × 10in)*
- *Charcoal stick*
- *HB pencil*
- *Kneadable eraser*
- *Cloth for wiping*
- *Paper to protect against smudging*
- *Stump*
- *Fixative*

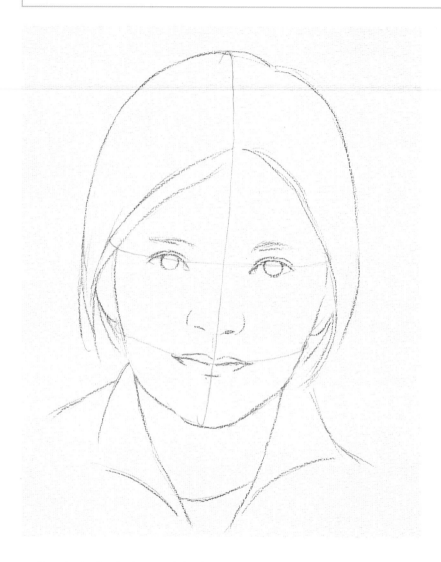

1 Use meridian lines to help with the positioning of the eyes, nose and ears.

1 Sketch the basic shape of the head – an egg shape. Next, determine the position of the eyes with the help of a meridian guideline. Use a medium-grade pencil for sketching and for the guidelines, as it is easier to erase than charcoal. Starting with the eyes, it is then easy to establish the correct places for the mouth, nose and ears. The inner shapes and the hair can also be quickly outlined. Using charcoal, transfer the dark hair and strong eyebrows, forming an attractive contrast to the delicate face and the bright eyes. The young woman is looking directly at the observer, making the intensity and liveliness of the eyes very apparent.

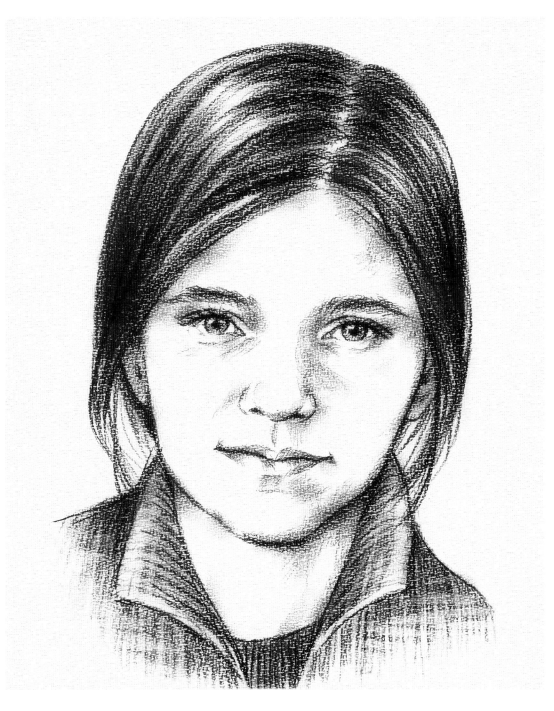

2 The shadows remain fairly soft at this stage. To give depth, press harder with the charcoal.

2 Using charcoal, add the shadows now with loose hatching. The daylight from the window on the left side casts some light shadows on to the right half of the face. This can be seen mainly in the area of the eye sockets, nose and around the chin. Next, draw in the eyes, eyebrows and hair. In the darker areas, such as the eyebrows and pupils, the charcoal is applied with greater pressure.

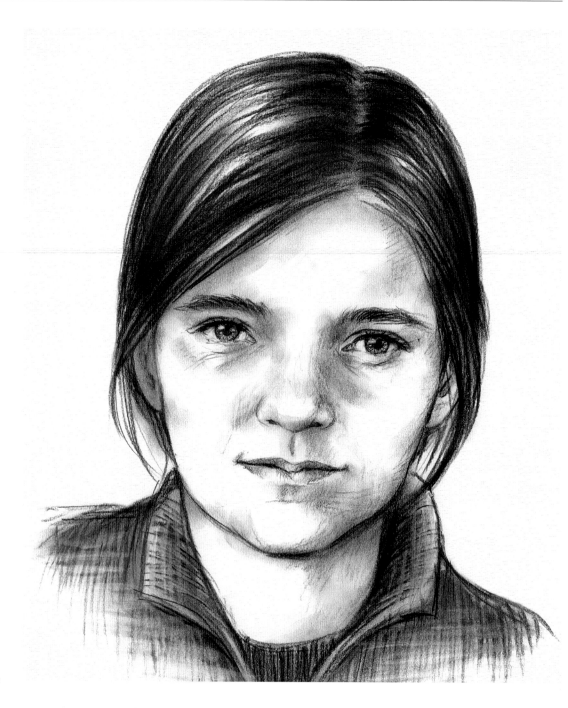

3 Emphasise the contours and details. The clothing is not drawn until the end to avoid smudging it.

3 Gradually intensify the shadows using soft hatching. Light tones and soft transitions can be achieved by smudging with your finger. The eyes are made stronger by pressing harder with the charcoal stick. Eyebrows, eyelashes and hair should also be emphasised with stronger strokes. The glints in the hair remain blank. For the very dark parts of the hair, the strokes can be smudged thickly into the paper, causing the pigments to penetrate into the indentations of the texture of the paper, making the areas appear completely black.

The contours of the face, nose and lips should now be emphasised. The cardigan and the T-shirt should be drawn at the end so that this part is not accidentally smudged when drawing the head. To avoid subsequent smudging, apply fixative to the completed drawing.

Step-by-step practice picture: middle-aged man

Materials required
- *Strong, slightly textured white drawing paper, about 21 × 28cm (8¼ × 11in)*
- *Charcoal stick*
- *Kneadable eraser*
- *Cloth*
- *Paper or foil to protect against smudging*
- *Stump*
- *Fixative*

For this drawing of a middle-aged farmer, your aim is to use charcoal to achieve the dark, deep tones and the rawness that is found in the face of a man living off the land. The half profile is a good compromise between profile and en face. It emphasises the characteristic shape of the nose, whilst retaining the impressive gaze directed at the observer.

1 Capture the rough outlines of the face using light lines.

1 First outline the rough egg shape of the head. The midline is shifted slightly to the left due to the turn of the head. Next, using a horizontal guideline, determine the position of the eyes. In this instance, the eyes are not exactly in the middle but a bit above. This 'shifting' depends on the individual proportions, as well as on the angle of vision, which is slightly from below in this case. The slightly open mouth also makes the lower half of the face longer. Once the correct position of the eyes has been found, the mouth, nose and ears are equally easy to draw in.

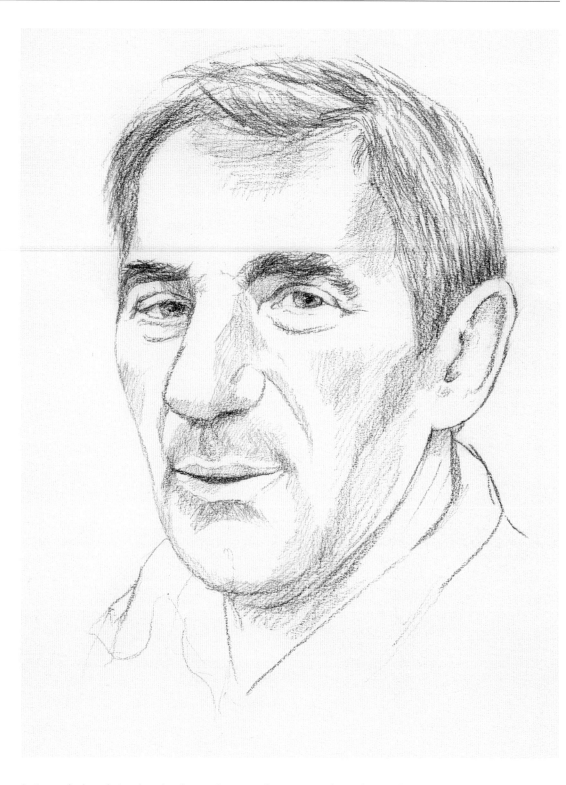

2 Shape the face with soft shadows.

2 Loosely hatch in the shadows. Due to the cloudy sky outdoors, the shadows are relatively evenly distributed over the face, helping to reveal the contours of the face. Draw in the eyes, eyebrows and hair. In the darker areas, such as the eyebrows or pupils, simply press harder with the charcoal.

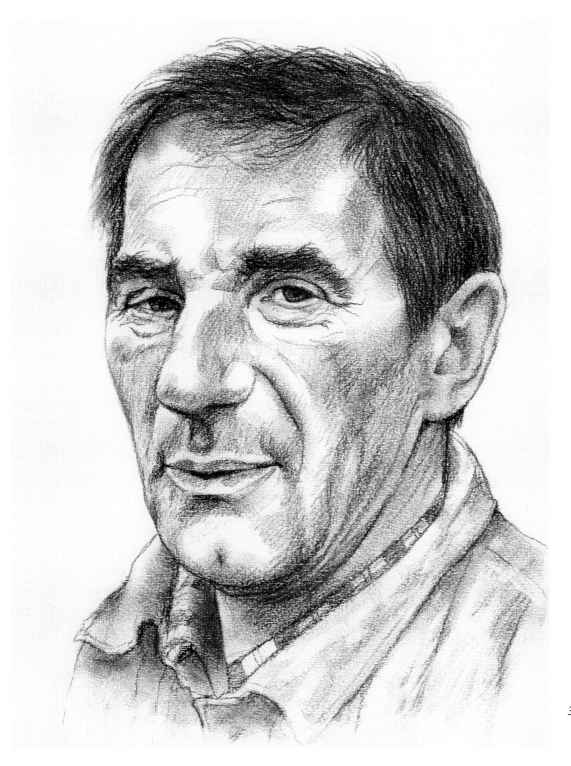

3 Emphasise the details and deepen the shadows as required.

3 Gradually intensify the shadows over the whole face using hatching. Light tones and soft transitions can be achieved by smudging with your finger. Strengthen the eyes by pressing harder with the charcoal stick. The folds of the eyelids, the nose and area under the chin should also be intensified. The eyebrows and hair are darkened using strong strokes. Draw the checked shirt and padded jacket at the end so that this part is not accidentally smudged when drawing the head. To avoid subsequent smudging, apply fixative to the completed drawing.

Lesson 5: drawing portraits using red chalk and sepia pastel

Red chalk and sepia pastel – materials and method of working

Learning goal
Learn to draw portraits using sepia pastel and red chalk. Capture the special characteristics and proportions of babies' heads.

Basic materials
- *Chalk pastels in one or two reddish, earthy shades and in black and white*
- *Sepia pastel (dark brown)*
- *Textured paper in beige, brown or a reddish shade*
- *Kneadable eraser*
- *Stump or paper tissue*
- *Fixative*

Red chalk and sepia pastels are ideal for portraits because they produce a very natural and vivid range of colours. Michelangelo and Leonardo da Vinci drew using these warm earth tones. Red chalk pastels are made from a fine **aluminium oxide** that contains ferric oxide. Depending on the amount of ferric oxide, red chalks have a **red to light brownish colour**. Sepia is a dark brown shade and you can also buy black and white chalk pastels.

Portraits can be drawn using just one or two shades of chalk pastel or using several colours ranging from black for dark areas via reddish and earthy tones through to white for highlights.

Red chalk pastels come in a **soft**, easily smudgable consistency and with added oil to make **firmer**, more precise pastels. These are difficult to smudge and erase. Red chalk pastels come in various forms: encased in wood, round like pastel crayons and as square chalk pastels. The square pastels have the advantage that you can draw fine lines using the edges, as is often needed for eyes and hair. The wide edge of a shorter piece is excellent for working on large areas.

Portraits in red chalk look the most impressive on **textured paper** in a warm shade, such as beige, a reddish shade or brown. To erase soft red chalk pastels, you need to use a **kneadable eraser**. You can also smudge using a **stump** (paper blender), your fingers or a **paper tissue**. To protect the finished drawing from accidental smudging, it should be treated with **fixative** when completed.

Practical exercise
Make a simple drawing using red chalk. For the darker shades, add dark brown. Add areas of light and shade using these pastels. You will see that your drawing appears more three-dimensional and therefore more realistic.

Step-by-step practice picture: baby

Drawings using chalk pastel in a warm red have a soft, light and delicate appearance. Red chalk is therefore an excellent choice for a portrait of a child or baby. In this example the whole head is deliberately not drawn. The very close-up nature of the content of the picture is designed to convey that all-important closeness and warmth in relation to the baby. A photograph was used here to work from, as other than when they are sleeping, babies seldom stay still. It is not easy to draw a baby. Everything about them is round and the facial features are not very concise. Even so, they are already little personalities and popular subjects – babies are constantly photographed by their parents. A human never changes so quickly as in his or her first months of life. Babies are therefore always rewarding subjects.

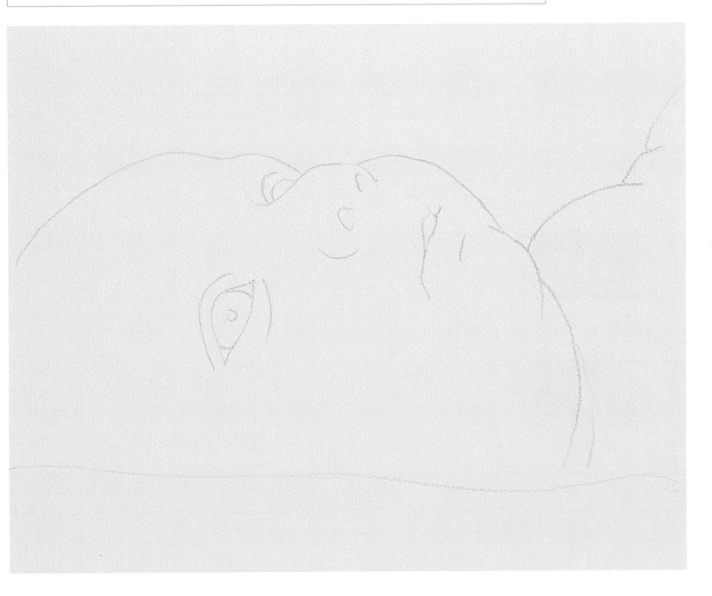

Materials required

✦ *Textured, lightly coloured drawing paper, about 24 × 30cm (9½ × 12in)*

✦ *Chalk pastel in a warm red shade*

✦ *Kneadable eraser*

✦ *Paper or foil to protect against smudging*

✦ *Stump*

✦ *Fixative*

1 Roughly transfer the shape of the head in half profile to the paper. If the proportions are right, then the lines can be perfected and the guidelines removed. Initial details, such as eyes and nostrils, can be inserted. If the head is larger than the size of the paper, as is the case here, it can be more difficult to capture the proportions correctly. You can make it easier by putting a larger sheet of paper underneath and completing the top of the head on this. The supine position of the subject is also unusual. We are more used to seeing faces upright and drawing them in that position too. That is why it can be easier to turn the photograph and the drawing paper upright and work from that position.

1 Roughly transfer the shape of the head to the paper.

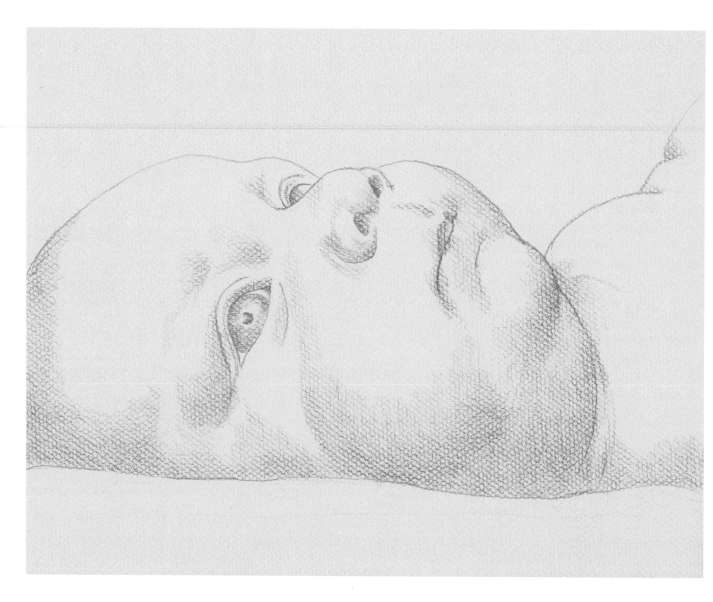

2 *Add the large shadows using the broad side of the pastel, running it over the grain of the paper.*

2 Now start working on the shapes of the baby's face by first inserting the largest shadows in the area closest to where the baby is lying. Do this by running the broad side of a short piece of red chalk pastel over the paper so that the pigments adhere to the raised areas. In this way, the grain of the paper gives a particularly nice effect. The smaller shadows around the nose and eyes are indicated using a blunt piece of red chalk pastel. Keep comparing your drawing with the photograph and check that the proportions are right.

3 Strongly emphasise the dark areas beneath the baby's head using the broad side of a short piece of red chalk pastel. Smudge the most intense areas of shadow with your finger so that the pigments penetrate into the indentations of the paper's surface.
As only a few shades of light and dark are possible with the exclusive use of red chalk pastel, you have to press firmly on the pastel for the dark contours and accents.

This causes the pigments to be transferred into the indentations of the paper and then the maximum darkness for this technique is achieved. This is necessary for the eyes, as well as the nose, mouth and some of the contours. The eyelashes and hair are drawn with the sharp edge of a square chalk pastel. Finally, the delicate drawing should be protected with a layer of fixative.

3 Create darker shadows by smudging or by increased pressure on the pastel.

Step-by-step practice picture: young man

Materials required
- *Textured drawing paper in yellow ochre, about 30 × 40cm (12 × 16in)*
- *Chalk pastels in red, brown and black*
- *Paper or foil to protect against smudging*
- *Stump*
- *Kneadable eraser*
- *Fixative*

The portrait of this young man was drawn on a sunny day by the sea. The wind is coming from the front and has tousled some strands from his tied-back hair. The sun, high in the sky, is casting some shadows around his slightly squinting eyes, as well as under his nose and chin. To convey the depth of these shadows and the man's dark hair properly, brown and black chalk pastels are used as well as red in this portrait.

1 Draw the egg-shaped head. The vertical midline is slightly shifted to the right due to the angle of the head.

1 In this half profile, the head is slightly turned to the side. Draw the shape of the head, based on an egg shape. Note that the vertical midline is shifted to the right. Set in place the horizontal guidelines for the facial features, and sketch the face over the guidelines.

Use a red chalk pastel for this, running it lightly over the paper, so that it can easily be erased. Once you have checked that the proportions are correct, the guidelines can be removed and the deepest tones around the eyes and the chin can be lightly hatched in red.

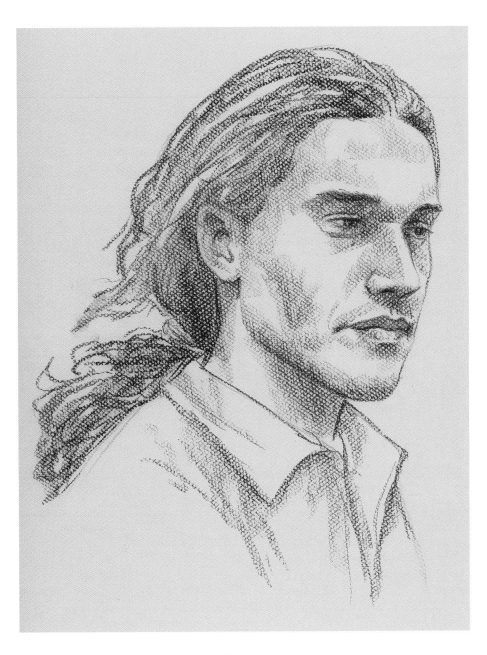

2 *Add the shadows using red and brown chalk pastels.*

2 Add the shadows on the face and neck by running a short piece of red chalk pastel along its broad side over the paper. The grain of the paper wears off the pigments to leave an even coverage with a clearly visible paper texture. In the darkest areas the shadows should be emphasised in the same way with a brown chalk pastel. Use the dark pastel to go over just some of the contours, such as the eyes, eyebrows and nostrils. The hair and the tones of the shirt can also be indicated using the broad side of the brown piece of chalk.

3 Now emphasise the shadows, making the face look more three-dimensional. Work equally with both the red and the brown chalks. The colours will overlap in places, forming new shades of reddish brown.

The loose hatching and the large scale of the work using the broad side of the pastel will produce soft transitions. The resultant facial features are vivid and three-dimensional in warm colours.

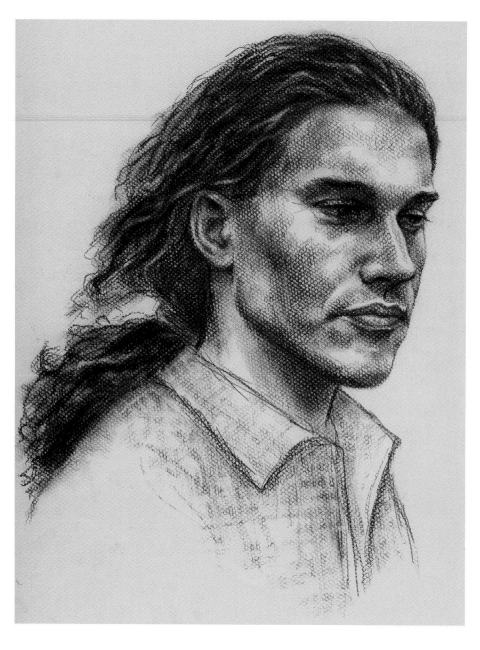

3 *Apply the colour of the hair strongly and smudge it into the paper grain. Add reflected light to the hair by working with the kneadable eraser.*

For the darkest accents, such as for the eyes or nostrils, apply strong pressure so that the pigment can penetrate the indentations of the textured paper. The dark hair is drawn with a large amount of brown. Finally, rub the colour into the paper well.

Where strands of hair are gleaming, erase the colour at the appropriate places using the kneadable eraser. Then draw in some strands in brown and black. Lightly shade the shirt using black and indicate the pattern using the kneadable eraser. Finally, spray the drawing with fixative to protect it.

Young woman in chalk pastel

Materials required

✦ *Textured drawing paper in yellow ochre, about 30 × 40cm (12 × 16in)*

✦ *Chalk pastel in a reddish shade*
✦ *Fixative*

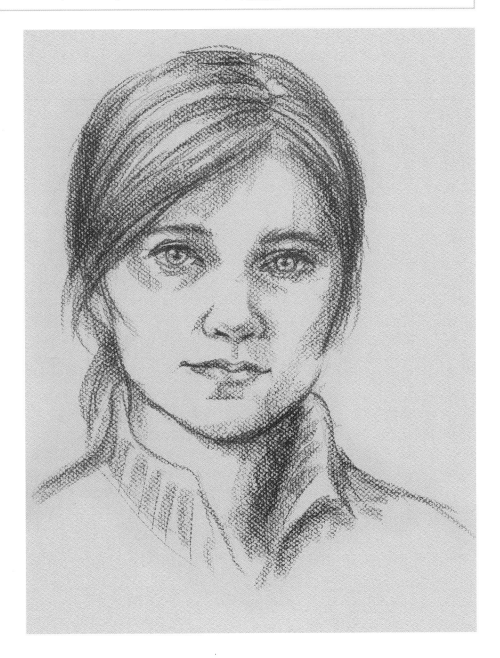

This expressive portrait is actually only a 15-minute sketch. It is of the same young woman as in the first practice piece in lesson 4 and clearly shows how different the effect can be when using another medium. The shadows were applied using the broad side of the red chalk pastel. The heavy grain of the paper has a creative effect because the pigments only adhere to the raised parts. For clearer contours, press more firmly with the chalk pastel to penetrate the indentations of the paper and fill them with pigment. To protect the picture, you can spray it with fixative when completed.

Girl with ponytail

Materials required
+ *Slightly grainy drawing paper in light brown, about 16 × 20cm (6¼ × 8in)*
+ *Chalk pastel in a reddish shade*
+ *Fixative*

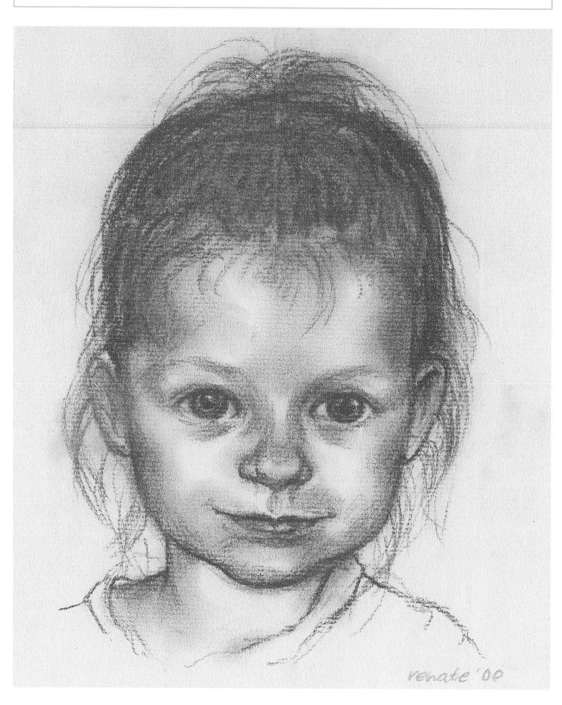

This portrait is made on textured drawing paper. The red chalk pastel is used more strongly in the darker areas. The face was given a three-dimensional effect by the placement of the shadows, which were loosely hatched and heavily smudged. This method brings out the round shapes of the girl's face really well. The drawing needs to be sprayed with fixative when completed to protect it from smudging.

Lesson 6: drawing portraits using coloured pencils and watercolour pencils

Coloured pencils and watercolour pencils – materials and method of working

Coloured pencils are ideal as an introduction to working with colour because they are easier to use than paints. They are also very practical when on the move.

The lead of a coloured pencil consists of colour pigments, a filler, such as chalk or talcum powder, a binding agent and wax. Coloured pencils come in both soft and hard grades. The **soft pencils** are particularly good for large-scale creations, while the **harder leads** are useful for drawing light lines and details.

A basic recommendation is **10 to 15 different colours**: as well as black and white, you need some brown shades for portraits, such as terracotta and ochre or sienna, for example. You also need Prussian blue, ultramarine, cobalt blue, dark carmine red, scarlet and cadmium yellow. You will also need an **eraser** and a **sharpener**.

Coloured pencils can only be **partially erased**. Only lightly applied strokes can be completely removed; others can be lightened to varying degrees, depending on the shade of colour.

The colour intensity is influenced by the level of pressure applied, but the selection of **paper** can also alter the tone: the colours will look lighter on smooth paper than on grainy paper.

Watercolour pencils are coloured pencils with water-soluble leads. They have the same properties as coloured pencils and can be used in the same way. However, they can also be used to achieve **paint effects** as with traditional watercolours. Three techniques are possible, which may be used individually or in combination:

- You can **dip the tips of the pencils in water** and draw on dry paper using the dissolved lead.
- You can draw on **wet paper** using a dry pencil. The lines will be stronger and the colour more intense.
- You can **dissolve with a wet brush** 'dry' lines and areas that have been previously drawn. This blends the colours, and individual strokes change into a lightly washed area of colour.

For all these techniques, it is best to work on a **watercolour pad** or other **firm paper** that will not lose its shape when wet.

As the colours become more intense when mixed with water, you should try dissolving the colours to be used in advance. That way, you will avoid unwanted surprises with colours that are too dark to look right with the skin tones of the sitter. Mop up areas that are too wet and any excess colour using a **cloth**.

Very different effects can be achieved using **crosshatching, freehand hatching** or a **large-scale application**.

As the pencils are **semi-transparent**, new **colours can be blended** on the paper by painting one colour on top of another or by hatching close to another colour. When doing this, do not place strokes of the same colour too close to each other, to enable the subsequent colour application to adhere better.

Learning goal
Learn how to draw portraits using coloured pencils and watercolour pencils; combine both materials to increase the effect.

Basic materials – coloured pencils
- *Coloured pencils in 10–15 shades*
- *Smooth and grainy paper*
- *Eraser*
- *Sharpener*

Basic materials – watercolour pencils
- *Watercolour pencils in 10–15 shades*
- *Watercolour pad or firm paper*
- *Watercolour brush*
- *Cloth*
- *Sharpener*

Practical exercise

Make a simple drawing using coloured pencils and then repeat the same drawing using watercolour pencils. Wash the second drawing and compare the different colour effects.

Step-by-step practice picture: girl

Materials required
+ *Pad of slightly textured white watercolour paper, about 21 × 29cm (8¼ × 11½in)*
+ *Fine to medium round watercolour brush*
+ *Eraser*
+ *Coloured pencils and watercolour pencils in yellow ochre, terracotta, natural sienna, dark brown, carmine red and Prussian blue*
+ *Cloth*

A sketch made on a train was used as the reference for this portrait. The girl is day-dreaming out of the window, her head supported on her arm, making for an attractive subject. This portrait is worked using both coloured pencils and watercolour pencils. When using watercolour pencils, you can give the drawing a completely different character by

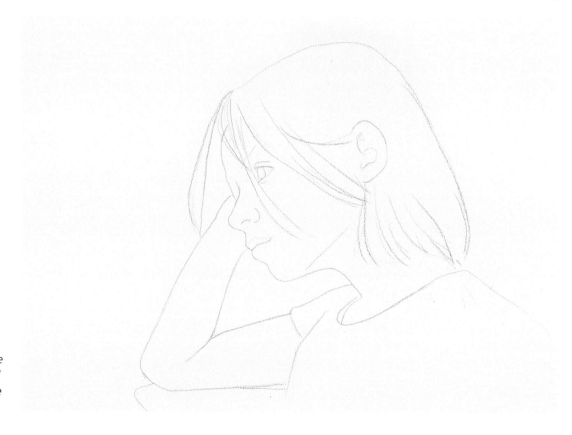

1 Plot the shapes of the face using a coloured pencil in yellow ochre or terracotta.

1 Sketch out the basic shape of the head in profile. In this case, it is an egg shape lying at an angle, as the head is slightly tilted. As this makes the proportions somewhat difficult to work out, it is important to measure up and compare with the subject (see page 17). In this way, the positions of the eyes, nose, mouth and ears are plotted. If the sketch is correct, the guidelines can be removed and the shapes of the eyes, ears and profile can be drawn. Use an unobtrusive colour for the sketch that can be a bit darker than the skin tone, for example terracotta or yellow ochre. You should, however, check in advance whether the colour you have chosen is easy to erase, so that you can make corrections. If not, then you can make the sketch using a pencil.

going over the drawing with water and a brush. The picture will then appear much stronger and the colours will be more vibrant. If you are drawing with coloured pencils only, step 3 completes the drawing – step 4 is only needed when using watercolour pencils.

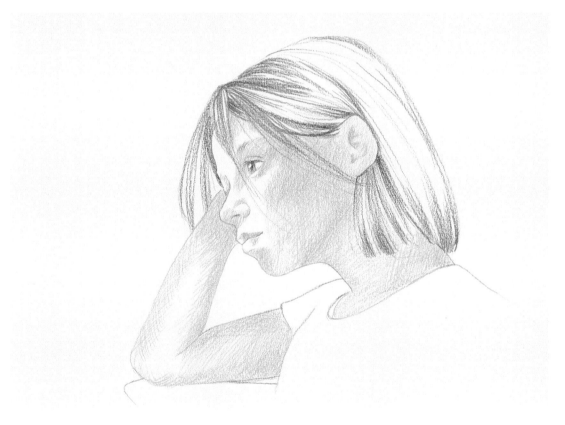

2 Remember to leave the light reflections in the eyes and hair blank.

2 Now lightly draw the facial features using terracotta and a light skin tone. Work using fine crosshatching and with strokes placed next to one another. Then apply the light skin tone before finally working on the darker parts in terracotta. Draw the eyes in brown, making sure that you leave the glint in the eye blank.

Next, draw the strands of hair precisely using dark brown. Here, too, the light-reflecting parts of the hair should be left blank. It is important at this stage that you keep comparing your picture to your sitter or the photograph/sketch because coloured pencils cannot be completely erased later.

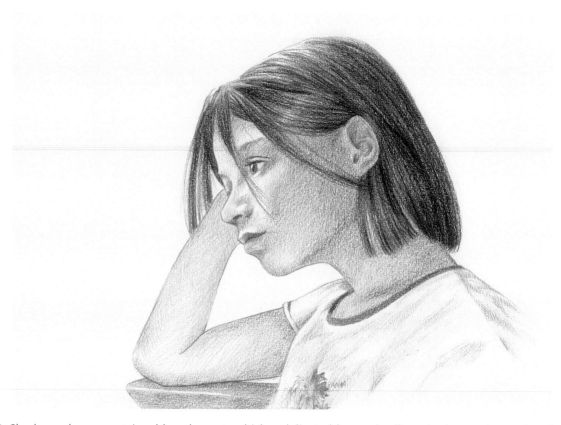

3 Use the wide edge of sharpened pencils in brown and black for the hair. The glints are left blank.

3 Shadows always contain a blue element, which is why the darker shadows are now emphasised by overlaying a light hatching in Prussian blue.

The cheeks have a fresh colour that can be re-created using some light red and terracotta. Some deeper shadows around the eyes, beneath the nose and at the chin can be drawn using terracotta, natural sienna and Prussian blue. The lips are in a stronger shade of pink and terracotta. The shadows along the arm should be lightly emphasised. The armrest is a combination of terracotta and brown, leaving the illuminated edge blank. The T-shirt is lightly drawn using delicate blue and yellow shades, and completed with a red-pattern and matching neck edge.

Go over the hair using sharpened pencils in brown and black. Shade dark areas using the broad edge, still leaving glints blank. As accents, draw some individual strands within the dark areas using fine, yet strong lines.

The coloured pencil drawing is now complete. To make a direct comparison between the artistic effects of coloured pencils and watercolour pencils, repeat the same drawing, this time using watercolour pencils. Repeat steps 1–3 then continue as in step 4.

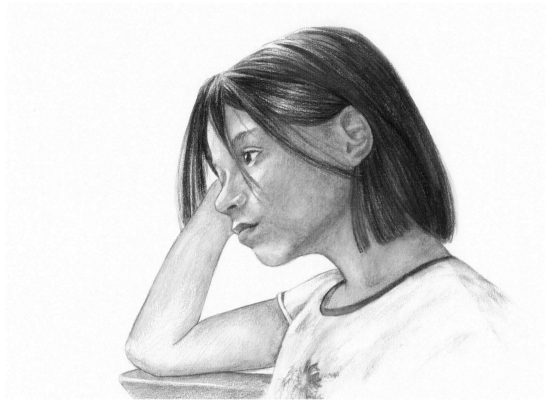

4 A wash makes the drawing in watercolour pencils appear darker and the colours stronger.

4 Watercolour pencils only

Using a wet watercolour brush, gradually start to wash the drawn parts of the arm, face and neck. Use the point of the brush to go along the contours and the thicker part of the brush to run softly into the middle. This avoids leaving fine edges around the areas covered with watercolour, which can spoil the effect, particularly with younger faces. For large areas of the face, for example the cheeks, these edges cannot always be avoided.

If the brush is only slightly wet there will be virtually no edges, yet when overlaying several areas, unwanted dark areas may form. This is why you should try out this technique beforehand. If the area is still wet, you can mop up excess colour and moisture with a cloth. If the colour is too dry, you can also try to dissolve it again using a wet brush. The edges that arise as a result of the wash can be deliberately used for effect, for example around the contours of the nostrils or the lips.

The hair is given a watercolour wash strand by strand, leaving the light reflections blank. In some places, you can also decide not to do a colour wash to achieve a different contrast. The armrest is barely touched; the roughness of the surface stands out from the texture of the skin and thus gives an indication of the wood.

Overall, the drawing becomes darker due to the wash, since the colours become stronger. If you want to make places darker later or alter the shades of colour, hatch over the dried parts using the dry or wet pencil. You can either leave the hatching over the washed area or partly or completely dissolve it with the brush.

Middle-aged woman

Materials required

- ◆ *Pad of rough-textured white watercolour paper, 21 × 29cm (8¼ × 11½in)*
- ◆ *Fine to medium round watercolour brush*
- ◆ *Cloth*
- ◆ *Eraser*

- ◆ *Watercolour pencils in dark red, violet, olive green, blue, terracotta, natural sienna, bronze, dark brown, blue-grey and dark grey*

First prepare a sketch setting out the correct proportions of the sitter. To give the subject more interest, choose the three-quarter profile. Position the figure closer to the left-hand side of the picture, so that she is slightly cut off.

Use the reddish watercolour pencils (terracotta, natural sienna and dark red) to create a warm, lively skin tone. Loosely run the pencils over the rough surface of the paper, so that the pigments just adhere to the raised parts (broken colour). This makes the colour application appear light and discreet.

The woman's greyish brown hair is drawn using shades of blue-grey, dark brown and dark grey. The applications blend optically when overlaid. Work step by step on the individual locks, taking care to include glints, as these are what make the hair appear natural.

The eyes are drawn in olive green and bronze. A pattern in the woman's clothes is indicated with light hatching in green, blue and violet.

When you are happy with the 'dry' work, start to wash your drawing. Proceed carefully using a round watercolour brush over the drawing, always washing the brush out before you work on a new colour area to avoid any unwanted blending of the colours. Have a cloth to hand to mop up unwanted runs.

When colour-washing the hair, follow the wavy lines of the watercolour pencils and leave some white areas in the front where the hair is thinning. This will give an illusion of depth.

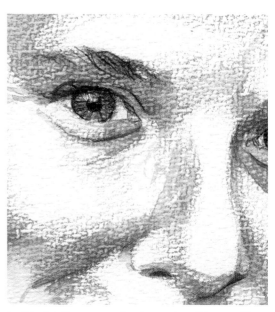

In this detail, you can clearly see the different effects of the partially dry, broken-colour application and the washed results.

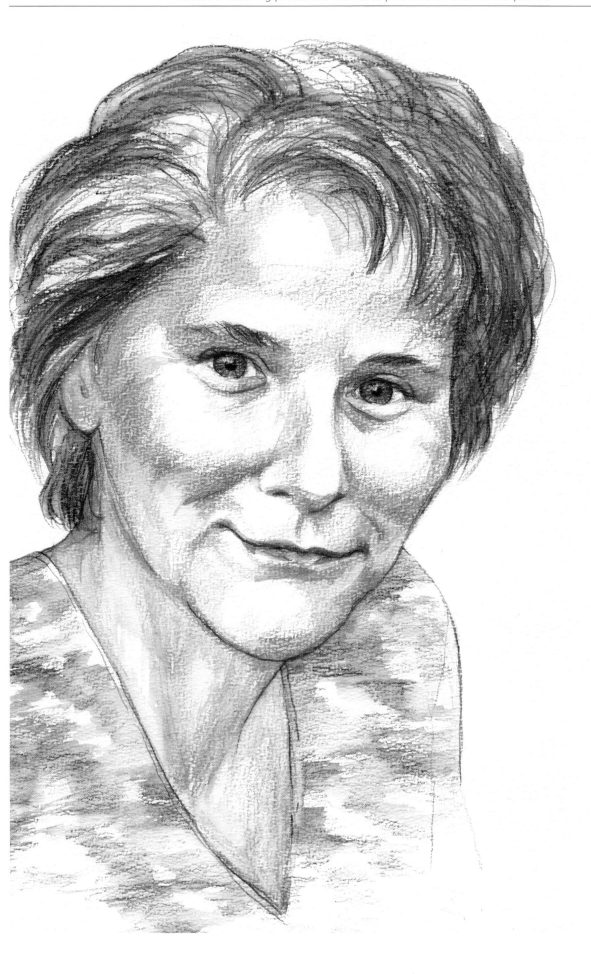